BANBURY
THROUGH TIME
Jacqueline Cameron

AMBERLEY PUBLISHING

Dedicated to the memory of Graham Wilton,
a talented photographer and a good friend

First published 2011

Amberley Publishing
The Hill, Stroud
Gloucestershire GL5 4EP

www.amberley-books.com

Copyright © Jacqueline Cameron 2011

The right of Jacqueline Cameron to be identified
as the Author of this work has been asserted in
accordance with the Copyrights, Designs and
Patents Act 1988.

ISBN 978 1 4456 0236 3

British Library Cataloguing in Publication Data.

A catalogue record for this book is available from
the British Library.

Typeset in 9.5pt on 12pt Celeste.
Typesetting by Amberley Publishing.
Printed in the UK.

Introduction

I have loved Banbury since the days of my childhood, most especially the Sunday school outings that were so much a part of growing up all those years ago. The outings were special occasions and a welcome break from religious instruction – actually the whole object of the exercise. They also gave mother a rest from my sister and I. Having grown up with the nursery rhyme 'Ride a Cock Horse to Banbury Cross', I've always thought the place has a special magic. Banbury was high on our list of places to visit on these outings. This would be followed by a stop on the Edge Hill for a picnic, with plenty of fun to be had in the trees around the turret. So I was very grateful to Amberley Publishing to be given the opportunity to write *Banbury Through Time* and, hopefully, share with you my memories of days gone by and show you how things have changed over the years.

On 30 November 1894 my grandmother, Bessie Jeffs, got married to my grandfather, George Cox from the Temperance Hall in Bridge Street. The couple lived in Ratley and Radway, so the family have a strong connection with the town and surrounding area.

To appreciate the history of Banbury, which stands on the border of Warwickshire and Oxfordshire, you have to look at the topography. Much of the area is on a slope, with the exception of the town itself, so every access to the town is downhill. Heavy clay and limestone deposits surround the town. In its early days, Banbury would have been dominated by the castle, which stood, as far as can be established, where the Castle Quay Shopping Centre now flourishes.

Built in the early twelfth century by Alexander the Magnificent, Bishop of Lincoln, the castle would have been most impressive. It was the seat of power in the area. It served a dual purpose as it was the town's jail. In the seventeenth century Banbury was notably Puritan and supported Parliament, which resulted in most of its inmates being criminalised. During the Civil War, one female spy was held here and was executed at Banbury during the war itself. One of the famous constables in charge of the castle was Thomas Chaucer, son of Geoffrey. In January 1554, a royal charter legally established the town as a borough and it was to retain a borough council until 1974. It is now a civil parish, with a town council first elected in 2000.

Twinned with Ermont in France since 1982 and Hennef in Germany since 1981, the town has two roads named in those towns' honour: Hennef Way and Ermont Way. The railway station in Hennef has been named Banbury Platz.

One of the places we visited on our Sunday school outings to Banbury was St Mary's church, which was built in the 1790s to replace the medieval one damaged during the English Civil War. The tower is currently covered in scaffolding and being repaired.

Geographically well-placed, Banbury has developed greatly since its early days as a Saxon settlement on the River Cherwell and has grown from a small country town to an industrial one. The Northern Aluminium Company opened up its rolling mill in November 1931 with a workforce of 200; by the time of the Second World War it had a headcount of 2,300.

In the 1950s, a new industrial estate was established on the Southam Road. Kraft Foods was built in 1964, and although it has changed hands from Alfred Bird & Sons and the Automotive Products Company, the factory is still sometimes known as General Foods, after the American company that originally owned the building. If you travel into Banbury by the Southam Road, the aroma of coffee fills the air. To a coffee lover like me, it smells beautiful.

Alcon also traded in the town. The Hunt Edmunds Brewery thrived for many years; lorries would go around the houses and estates selling beer to customers in their homes. Certainly it was a day my father always looked forward to.

A retailing revolution hit the town. Many of the old, locally owned businesses have been replaced by national firms. They are mainly housed under one roof, the Castle Quay Shopping Centre, which was developed in the mid-1970s.

In the Victorian period, Merton Street was home to Western Europe's largest cattle market. The market was formally closed in 1998 after being unoccupied for several years.

The town's Horton General Hospital was built in 1872 and was expanded in 1964 and again in 1972. Dating back to the Victorian period, it narrowly escaped closure in 2005.

Reputed to be the oldest working dry dock on the inland waterways of Britain, Tooley's Boatyard was established in 1790 to build and repair the wooden horse-drawn narrow boats that plied the newly constructed canal network. Tooley's is now run by a private company that has a 200-year-old blacksmith's shop and conducts its business behind the Castle Quay Shopping Centre.

I remember as a child watching the poor old horses pulling the narrow boats up and down the canal. The horse would walk on the tow path, pulling the boat behind him on the canal, usually loaded with coal, coke, seed or even industrial material. At the rear of the barge was a compact living quarter that always had beautiful painted plates, pots, pans, and fancy mirrors hanging on the open doors to the cabin. Looking back, I wonder how families managed to live like this. Not only did the boatman and his wife live on the boat; sometime large families did. The boats and their occupants held great fascination to us as children and we all made friends with boat children and spent hours on the canal bridge looking for our friends to pass beneath us. Later the horses were replaced by engines and these would pull two narrow boats rather than the one boat a horse could manage.

Banbury has had many crosses in its history. The High Cross, the Bread Cross and the White Cross were all destroyed by Puritans on 26 July 1600. Banbury was to remain without a cross for more than 250 years. The nursery rhyme 'Ride a Cock Horse to Banbury Cross' refers to one of the crosses. In 2005 Princess Anne unveiled a large bronze statue depicting a fine lady upon a white horse, which stands just yards from the present Banbury Cross.

To commemorate the marriage of Princess Victoria to Prince Frederick of Prussia, the current cross was built in 1859. The Gothic monument stands on the corner of West Bar and South Bar.

Banbury has become a commercial and retail centre for the surrounding area, which is predominantly rural. The main industries, apart from those mentioned, are car components, electrical goods, plastics, printing and processing.

Known affectionately as Banburyshire, the area has played host to the Annual Banbury Hobby Horse Festival since July 2000. This rather unique festival includes a gathering of mock animals from around the UK.

I have described our Sunday school outings, but I neglected to mention the real reason for our love of Banbury. Parson's Street was the home of Brown's Original Banbury Cakes. They were delicious. E. W. Brown has been associated with the Original Banbury Cake since 1868, but the family connection goes back to 1818, when the Quaker Samuel Beesley purchased a bakery business from Betty and Jarvis White. Evidence suggests that the bakehouse goes back to the early thirteenth century, a time when the crusaders brought back spices and dried fruit from the East. Similar to Eccles cakes, but oval in shape, the cakes were made from Brown's original recipe, which included wheat flour, vegetable fat, butter, Greek currants and fruits, cane sugar, spices and natural flavourings.

As well as Original Banbury Cakes, there are two lesser-known foodstuffs associated with Banbury. Mr J. H. Leach, who conducted his business on the High Street, specialised in Banbury Rock. Banbury Cheese, meanwhile, was first heard of in 1430, when fourteen such cheeses were sent to the Duke of Bedford's household in France. It must have been a good cheese, as they used a gallon of milk for approximately one pound of cheese. Almost white in colour, about an inch thick, and resembling soft cream cheese, it was worthy of a mention in Shakespeare's *The Merry Wives of Windsor*, albeit as an insult.

I have loved my trip down memory lane and the opportunity to spend more time in this lovely old town. It is steeped in history and this becomes apparent when you see the mixture of old and new buildings scattered around the town.

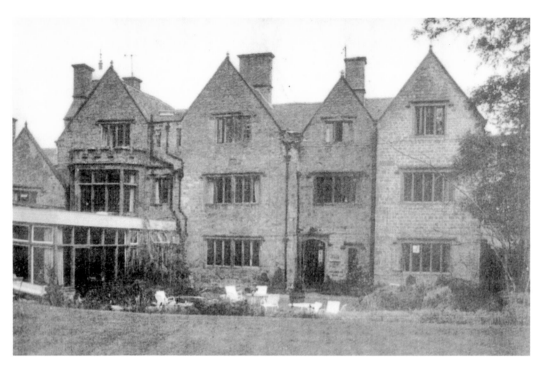

Whately Hall Hotel

Two different views of Whately Hall Hotel, of the back and, years later, the front. Many years ago I came to Whately Hall for an evening meal. On the menu was cold avocado soup and I can truthfully say I have never had another cold soup since that day.

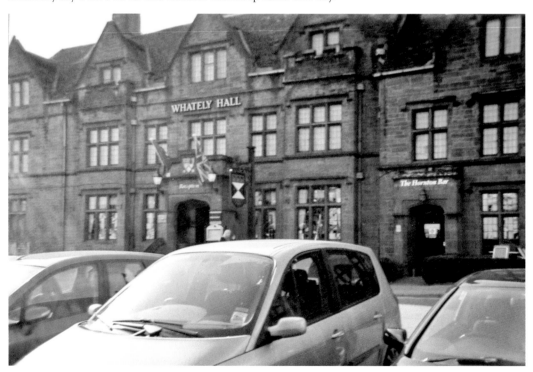

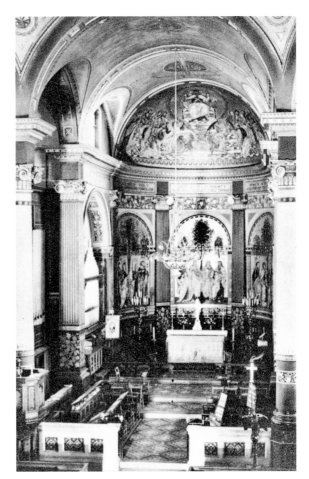

St Mary's Church

The altar of St Mary's church, which was built on the site of an earlier Gothic church in 1797. The erection of the tower did not take place until 1829 due to a shortage of funds. The photograph below shows the church as it looks today. The top of the tower is under repair.

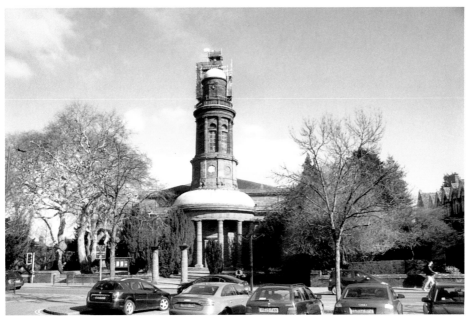

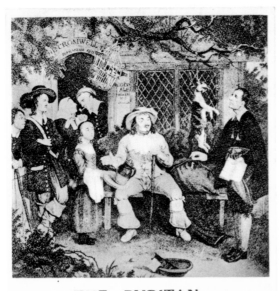

THE PURITAN

To Banbury came I, O Profane One
Where I saw a Puritane One
Hanging of his Cat on Monday
For killing of a Mouse on Sunday.

'The Puritan'
Banbury was famously sympathetic
to the Puritan movement. Below is a
general view of the town.

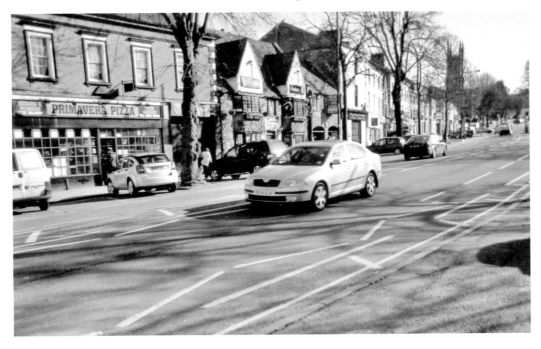

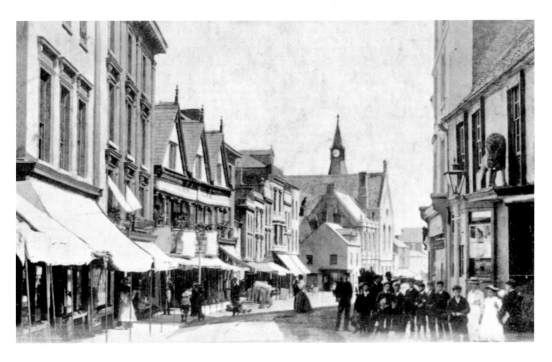

The High Street (I)
Two contrasting views of the High Street. How things have changed over the years.

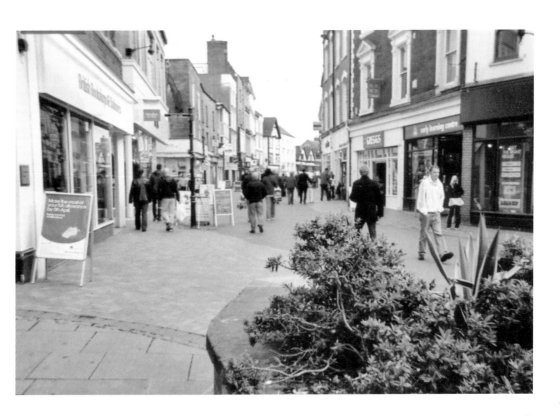

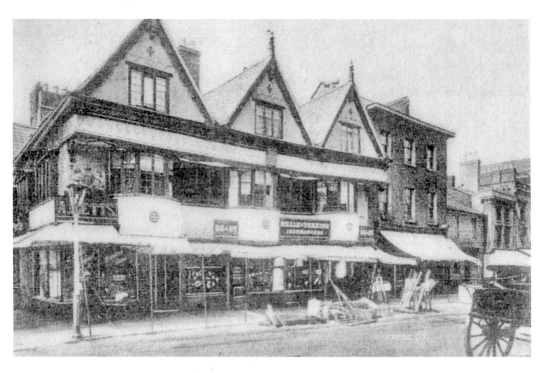

Betts (1)

The house of cloth merchant Edward Vivers, one of Banbury's most obdurate Quakers, stands in the High Street. This beautiful gabled house was built in 1650 and Vivers was imprisoned in 1665. From 1868, the house was to be known as Betts Cake Shop.

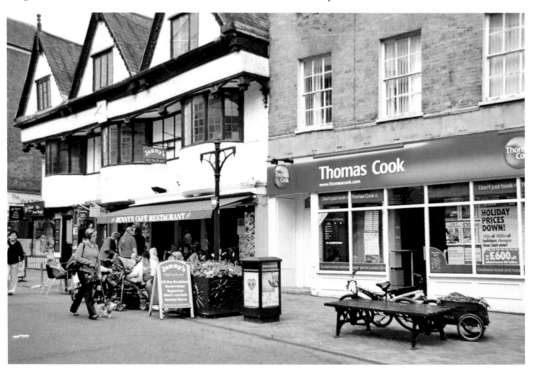

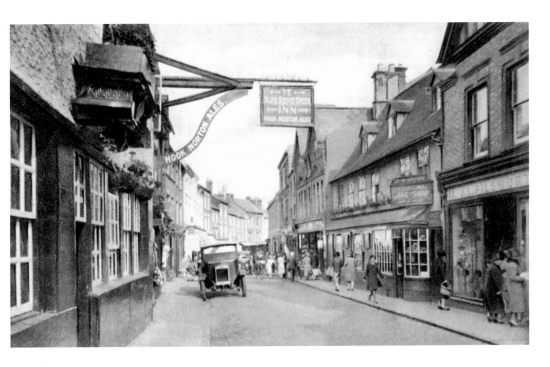

Ye Olde Reindeer Inn

Without a doubt, Ye Olde Reindeer Inn is the oldest building in Banbury. Situated in Parsons Street, the inn has remained unchanged for centuries. It stood opposite the town's famous cake shop. I have visited the inn many times over the years and the inside of the building has a charisma and charm of its own. The food isn't bad either.

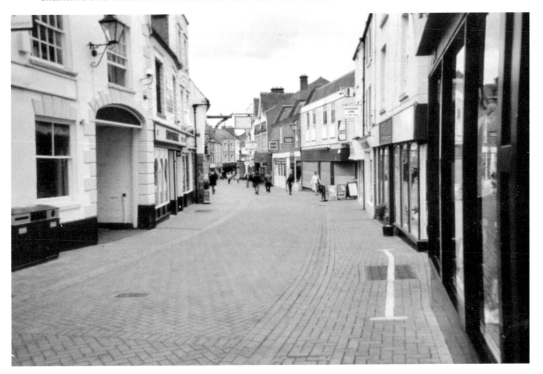

Brown's Banbury Cakes

The logo for Brown's Original Banbury Cakes. The shop can be seen in the Banbury postcard below.

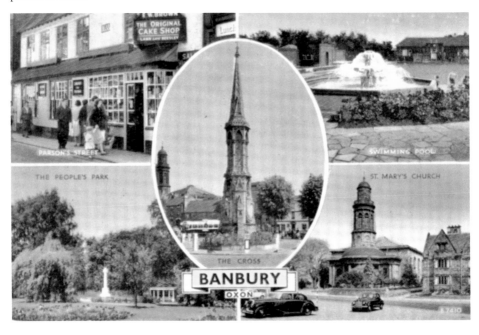

People's Park (I) and St Mary's Church
The photograph above is of People's Park; below is St Mary's church.

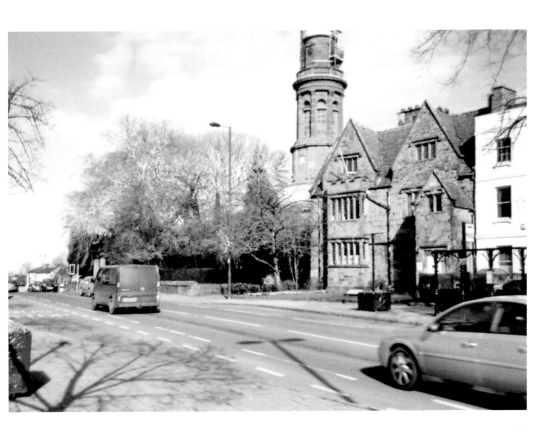

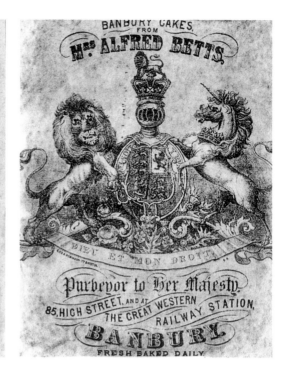

TELEGRAMS: "EWINS, BANBURY."
PHONE: No. 11.

EWINS & SON

Coach and . .
Motor Works.

Works :—MARLBOROUGH PLACE.

Office : —31, HIGH STREET.

CARS FOR HIRE

BANBURY CAKES
FROM
Mrs ALFRED BETTS

DIEU ET MON DROIT

Purbeyor to Her Majesty.
85, HIGH STREET, AND AT THE GREAT WESTERN RAILWAY STATION,
BANBURY
FRESH BAKED DAILY

Banbury Businesses
Just four of the many small businesses that traded in the town in the early twentieth century.

TROLLEY & SONS
PORK BUTCHERS,
Pastrycooks & Confectioners,
92, High St. & Bridge St., BANBURY.

MANUFACTURERS OF THE
CELEBRATED PORK PIES,
SAUSAGES,
AND
BANBURY CAKES.

Dining & Refreshment Rooms
HOT JOINTS DAILY.

MAKER OF ALL KINDS OF CAKES & PASTRIES.

HOT AND COLD BATHS.

92, High St. & Bridge St., BANBURY.

MRS. A. BETTS,

Banbury Cake Maker
and

Confectioner,

85, High St., Banbury.

Bride, Lunch, Madeira Cakes, &c.,
ALWAYS ON HAND.

POUND, CHRISTENING, AND OTHER CAKES
Made to Order.

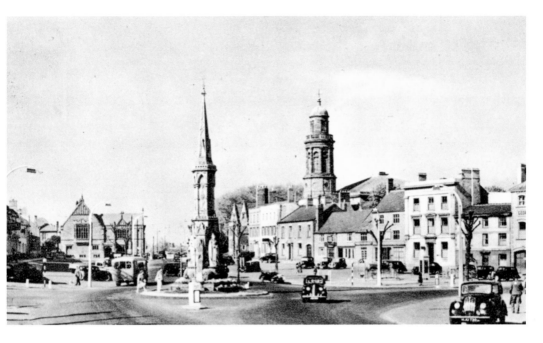

Banbury Cross (I)

There have been four crosses in the history of the town – the High or Market Cross, the Bread Cross, the White Cross and the Banbury Cross. 'Ride a Cock Horse to Banbury Cross' played a large part in my childhood. Mother would recite nursery rhymes to us as children and I had visions of a white lady upon a white horse. The present cross was built in Horsefair in 1859.

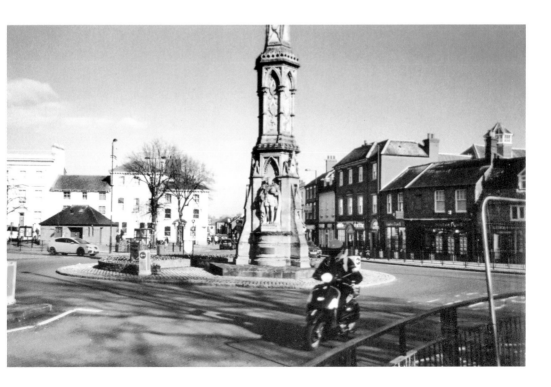

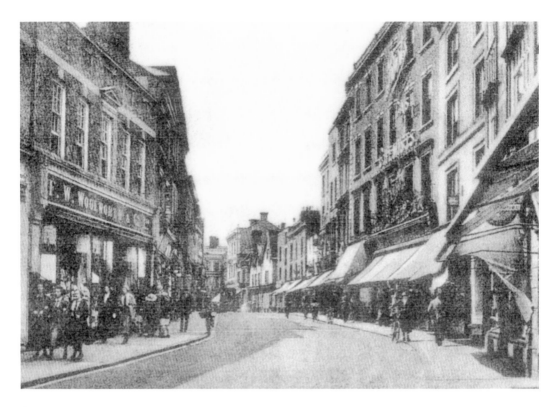

Woolworths

Alas, we no longer have the Woolworths store on the High Street. Photograph above shows Woolworths up and running; the photograph below shows how the street looks today. Where Woolworths once traded is now a branch of Mothercare.

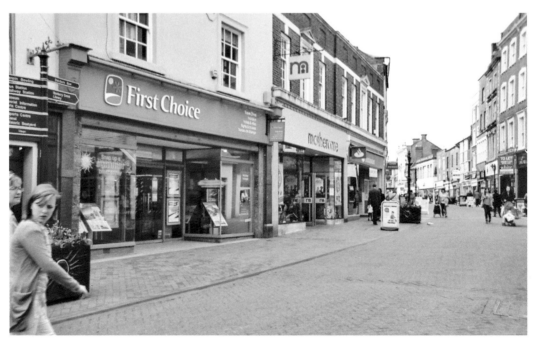

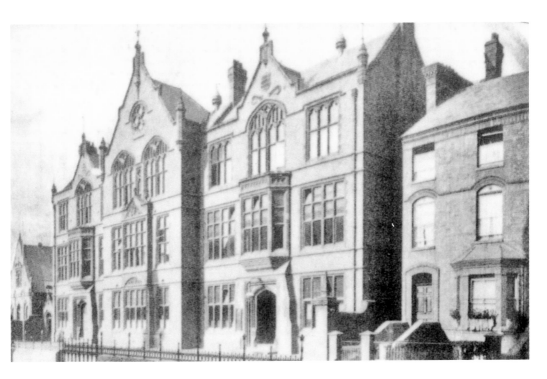

Mechanics' Institute and Technical School

Situated in Marlborough Road, this beautiful building to the right was built and given to the town by Sir Bernhard Samuelson, an ironmaster, for the benefit of his employees. In 1893 the building on the left was opened as a secondary and technical school. It was known as the Municipal School and was the forerunner of Banbury School. The building to the right now houses the town's library, the one on the left the offices of *The Four Shires*, a local magazine.

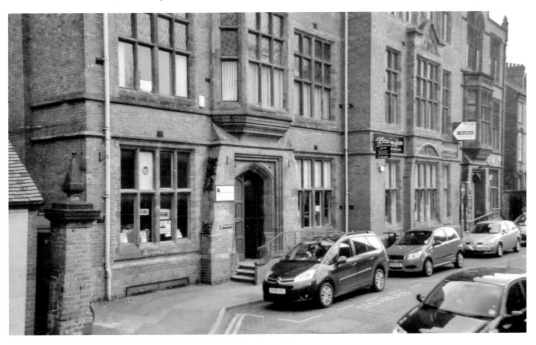

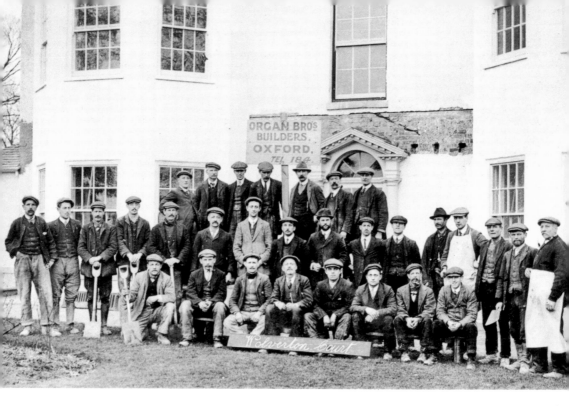

Organ Brothers

In the picture above we see the employees of Organ Brothers of Oxford. The school photograph below was taken from a collection I inherited.

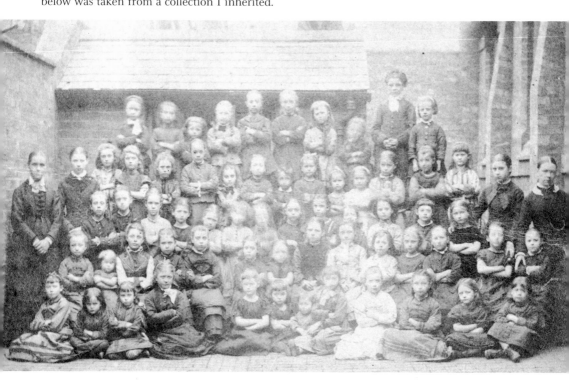

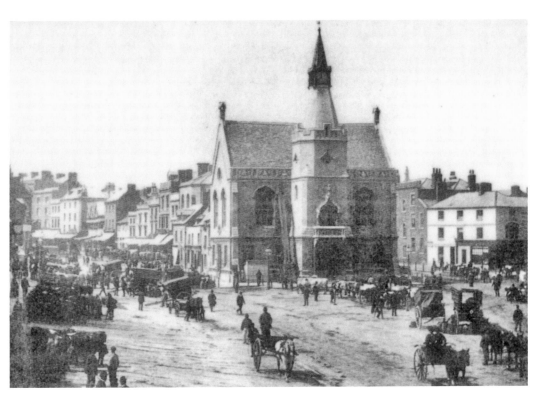

Town Hall

Built on the site of an old refuse pit, the New Town Hall in Bridge Street was the fourth to be built. Mayor Thomas Draper laid the foundation stone on 29 July 1853. In 1860 a clock was added. The building was extended in 1889 to house a new council chamber. The previous town hall was moved to Lower Cherwell Street, where it is used as a warehouse.

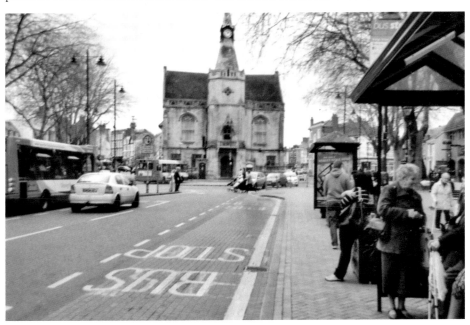

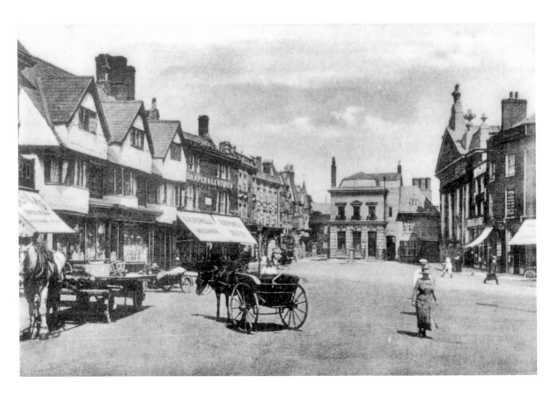

Market Place
Here we see the Market Place and Cornhill. The horse and cart has been replaced by the motor car and white arrows and parking lines have been introduced into our lives.

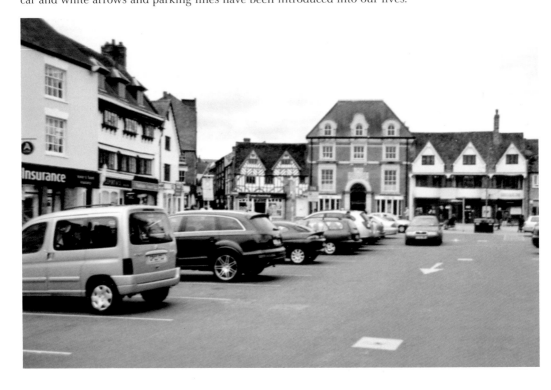

The Original Banbury Cake Shop

The town has long been associated with its cakes and the Banbury cake was a special favourite. Looking a lot like the Eccles cake, the Banbury cake dates back at least to the reign of Elizabeth I. Thanks to the efforts of Samuel Beesley, the owner of the shop, the cakes were exported to America, Australia and India during the mid-nineteenth century. The site is now known as Fashion Fabrics.

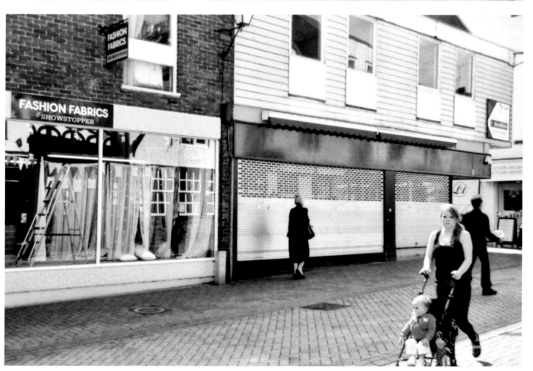

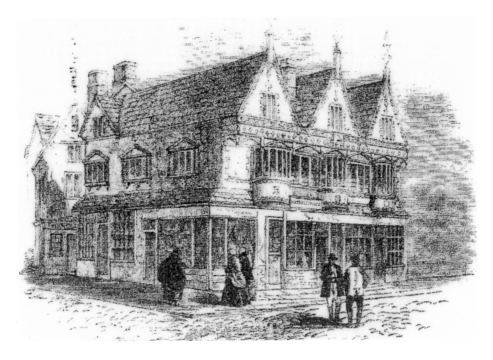

The High Street (II)

Two views of 85–7 High Street. While little is known about the picture above, the drawing below was made in 1840. The sign reads, 'T. Goffe, Tailor'. The shop next door belonged to Billy Watson, a shoemaker. He also kept a registry office for servants. A curious character, methinks.

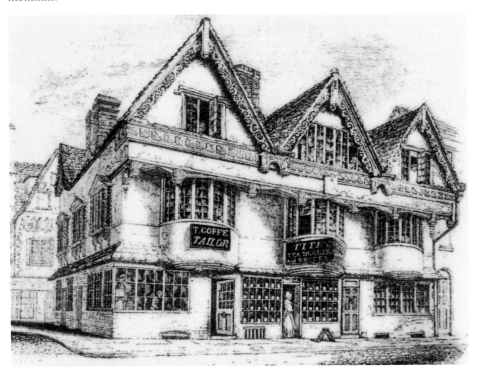

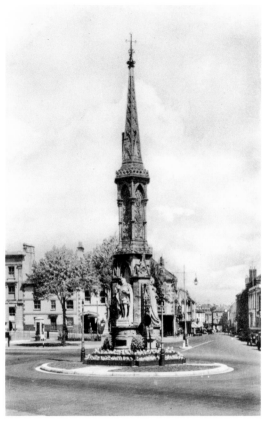

Banbury Cross (II)
The Banbury Cross was erected in 1859 to commemorate the marriage of Princess Victoria to Prince Frederick William of Prussia.

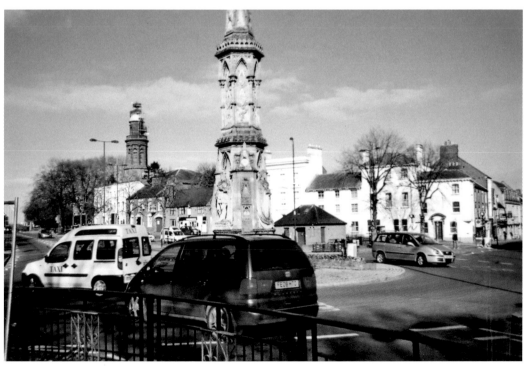

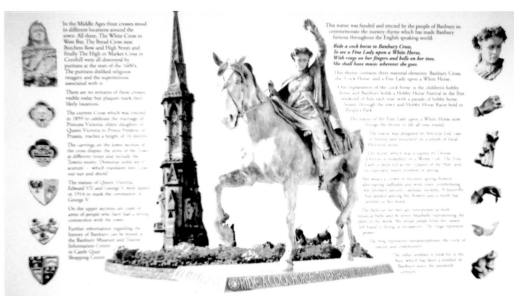

RIDE A COCK HORSE TO BANBURY CROSS TO SEE A FINE LADY UPON A WHITE HORSE
WITH RINGS ON HER FINGERS AND BELLS ON HER TOES SHE SHALL HAVE MUSIC WHEREVER SHE GOES

Banbury Cross (III)

Here we see the Banbury Cross and Horsefair.

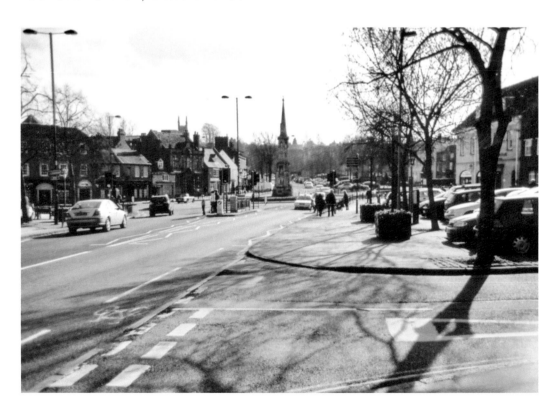

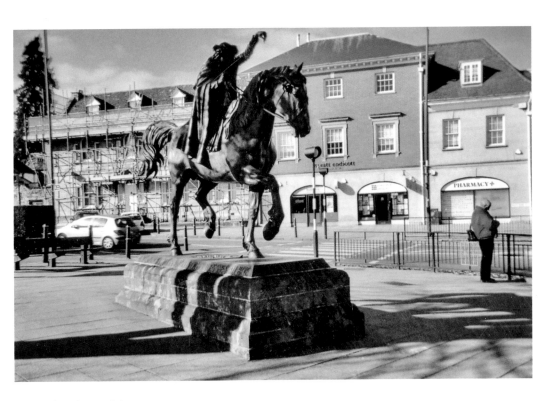

'The Fine Lady'

Here is Banbury's bronze statue of the 'fine lady upon a white horse' from the famous nursey rhyme. In contrast, watching the world go by, is Charlie Brown and his owner Andrew Bywater, whom I came across enjoying the sunshine by the statue.

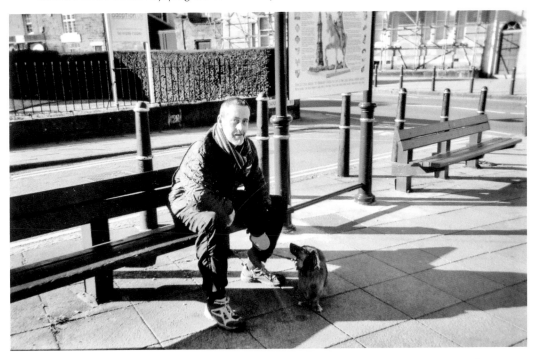

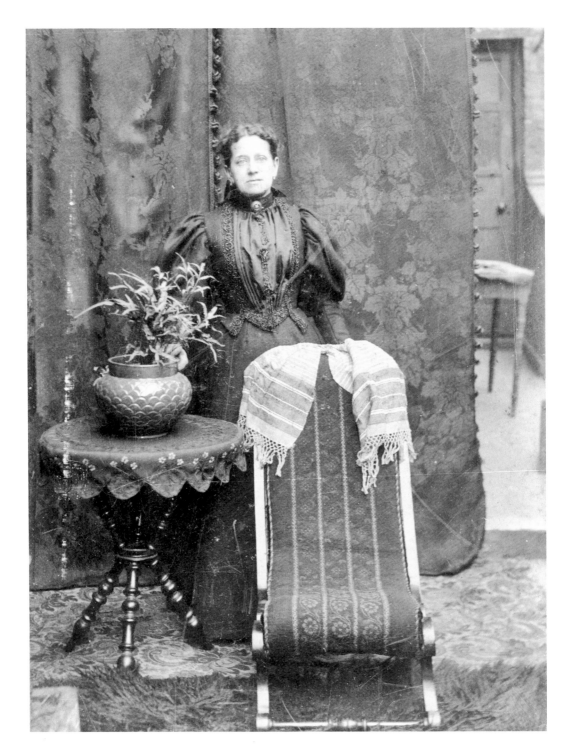

A Beautiful Lady

The collection of lovely old photographs from which this was selected was passed on to me by a lady whose family were Banbury people. She has no idea who the people are, other than that they are her distant relatives. This old photograph shows a beautiful lady in a studio somewhere.

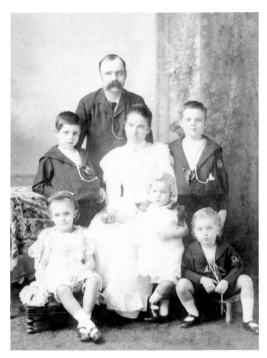

The Luker Family

Above left are the Luker family in India. Right is Miss Harriet Sly. The photograph below is of the private school that stood in the Market Square.

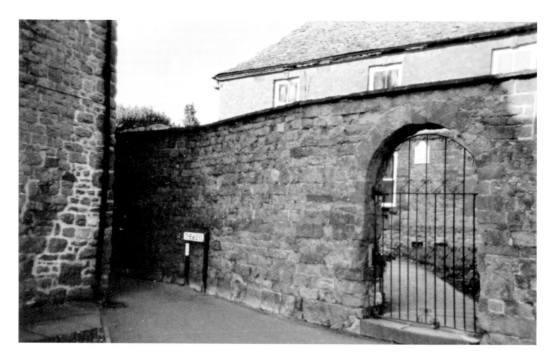

People's Park (II)

The result of a legacy left to Banbury Corporation by George Ball, a local chemist, the park first opened in June 1912. After expansion, the completed site was officially opened as part of the peace celebrations at the end of the First World War in 1919. Alas, due to cost-cutting, the 1931 bandstand and the paddling pool have now gone, the latter replaced by a climbing frame. Just take a stroll down the Leys and you will come across this lovely corner of Banbury.

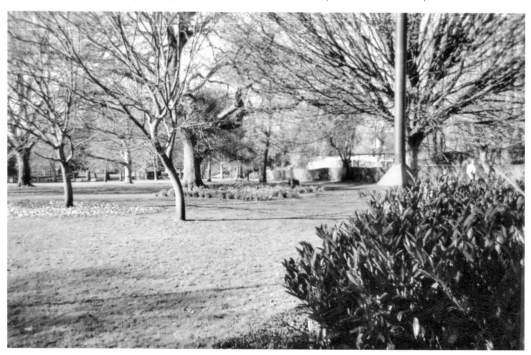

The Skelseys

As lover of pot plants I was delighted to find an old photograph of Ann Skelsey and her collection of pot plants, taken in Banbury in 1830. The photograph below shows her ancestors in the 1930s: Ivy, Phil and Rhoda Skelsey. The three siblings grew up in Box Hedge Lane.

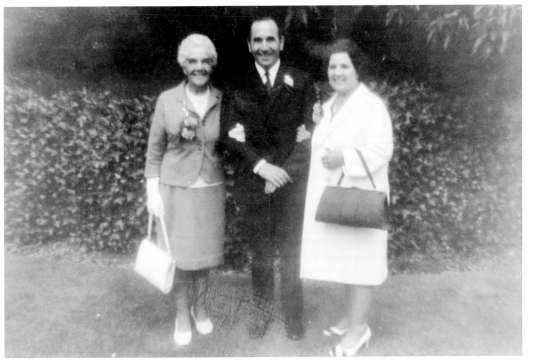

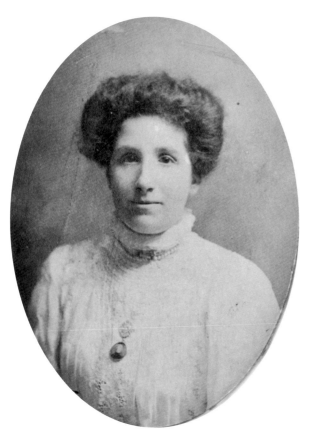

Granny Davis
A delightful photograph of Granny Davis as a young lady. In the photograph below we see her many years later enjoying a picnic with her friend Kate Hatton. Both ladies lived in Box Hedge Lane.

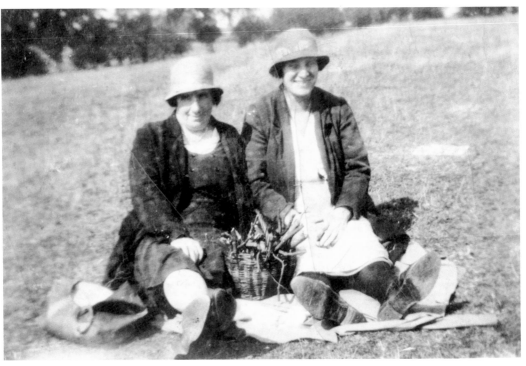

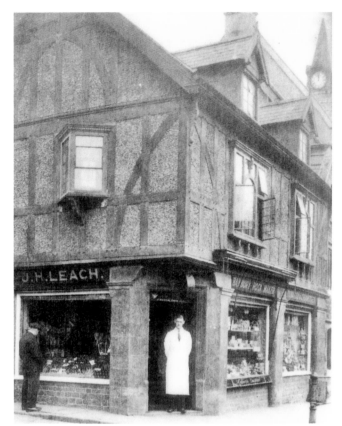

Mr Leach
Here we see the famous Banbury rock maker Mr J. H. Leach standing in the doorway of the shop on the High Street. The photograph below is of the Cargo Home Shop, one of the few remaining old buildings in the town.

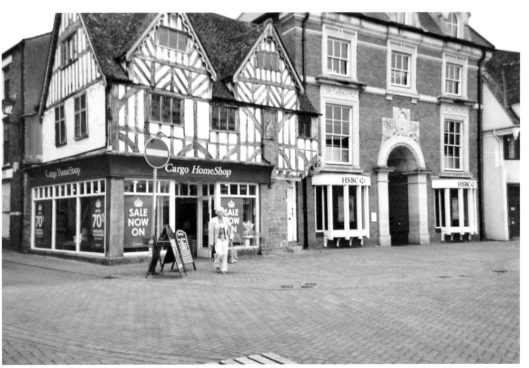

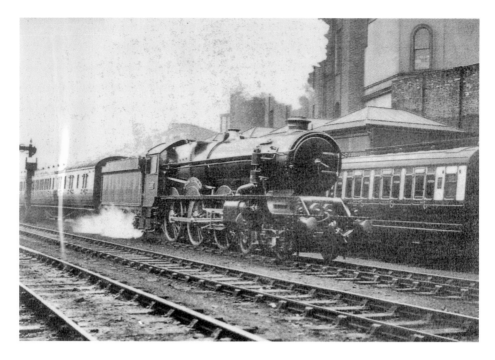

Banbury Station

At one time Banbury had two railway stations, Banbury Merton Street station on the London & North Western line, closed in December 1964, and Banbury station on the Great Western Railway line, which is still open. The GWR began its service from Banbury on 2 September 1850, with trains taking just over two and a half hours to reach Paddington. L&NWR, which later became part of London, Midland & Scottish, arrived in the town after much public pressure. For the train buffs I have included this delightful postcard of 4-6-0 No. 6000 *King George V* on its very first journey on 27 July 1927.

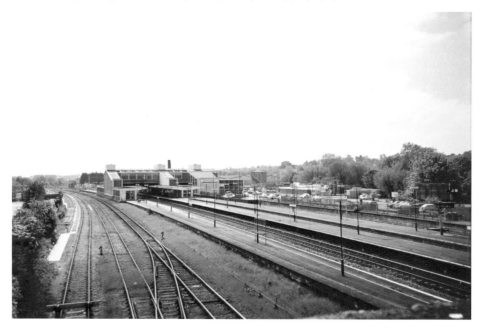

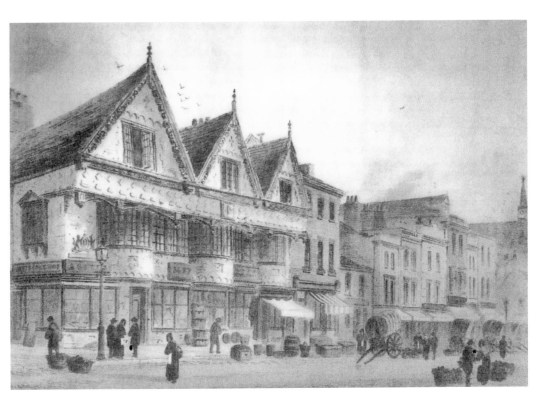

Betts (II)

Here we see Betts in the High Street. The company was appointed the official supplier of Banbury cakes to the royal household. The shop proudly displays the royal coat of arms.

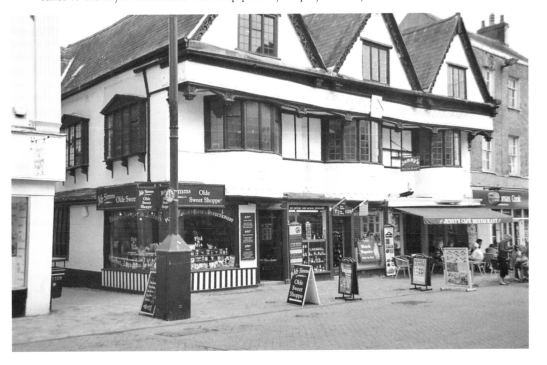

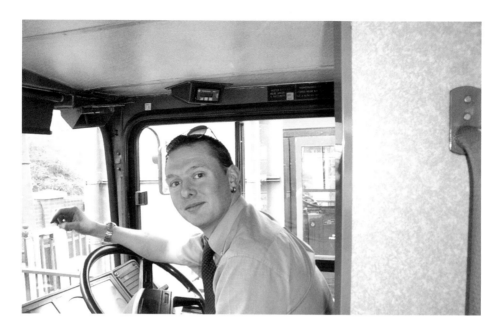

Banbury Bus Station

Buses are one of the main means of transport into the town, and the station is very well patronised. Here we see Stagecoach driver Colin Batchelder and his double-decker bus, which he has just driven into Banbury from neighbouring Leamington Spa.

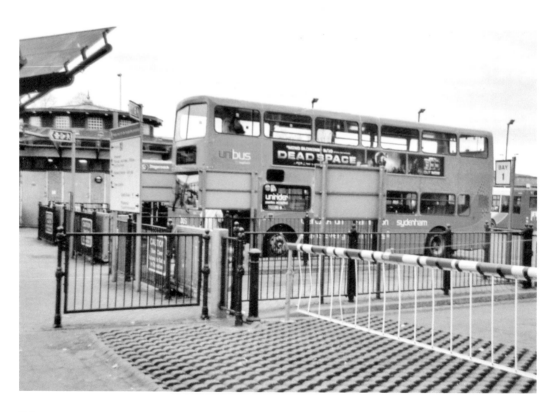

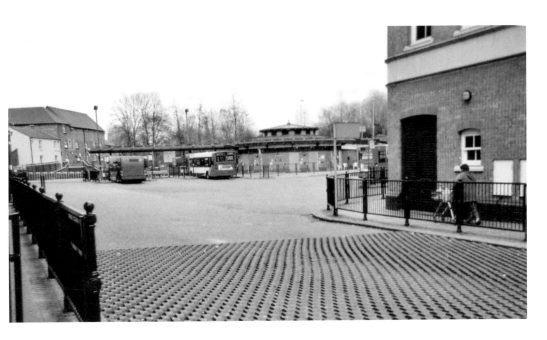

The Temperance Hall

The photograph above shows the bus station in Banbury and the photograph below shows what is left of the old Temperance Hall, which stands at the entrance to the bus station. The 'Baths Hot & Cold' sign is all that is left of the hall itself. It is here that my grandmother got married in 1894.

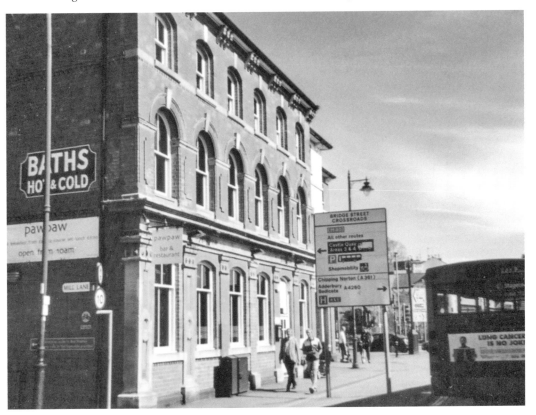

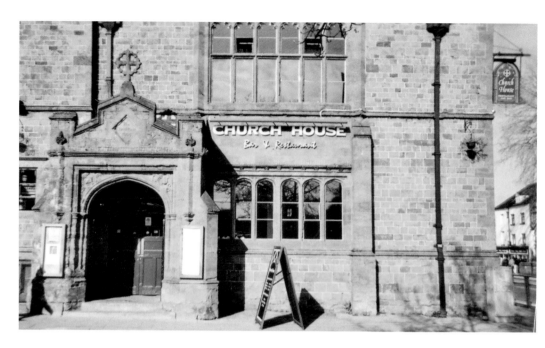

Church House

The delightful Church House has been converted into a restaurant and bar. It was built on the site of old houses in 1904–05 to provide St Mary's church with an impressive public hall. Designed by W. E. Mills in the attractive Late Gothic style, it was built in Hornton Stone.

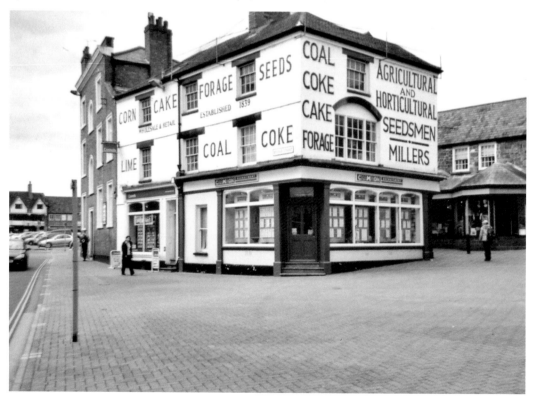

Wroxton Abbey and Warmington Church

In the village of Wroxton, off the Stratford-to-Banbury road, you will find ornamental gates at the end of a long drive from Wroxton Abbey (which was once a priory). This was once the home of Lord North, who was Prime Minister from 1770 to 1782. Warmington church, below, stands on a hill near Banbury 600 feet above sea level. The church register dates back to 1636. A stone in the churchyard is for a Royalist killed at the Battle of Edge Hill on 2 October 1642.

Tooley's Boatyard

Tucked away in a corner on the perimeter of the Castle Quay Shopping Centre is Tooley's Boatyard, a delightful step back in time for anyone lucky enough to stumble across it. The boatyard opened in 1790, twelve years after the arrival of the Oxford Canal itself. Until the decline of commercial traffic in the 1930s, narrow boats were built here. The boatyard is incorporated in the new Banbury Museum Heritage Centre. In the photograph below we see Matt Armitage, who is co-owner of the boatyard today.

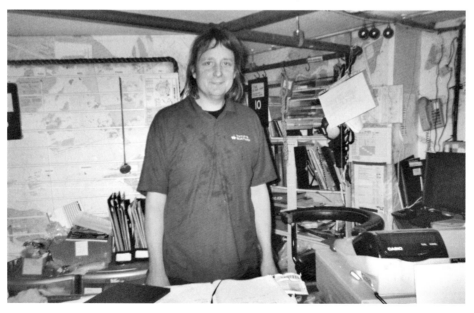

Tooley's Workshop
Inside the quite delightful workshop at Tooley's. It is full of charm.

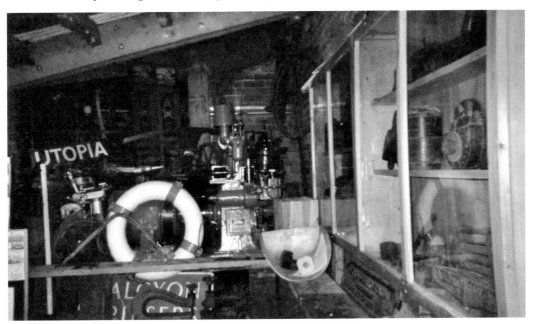

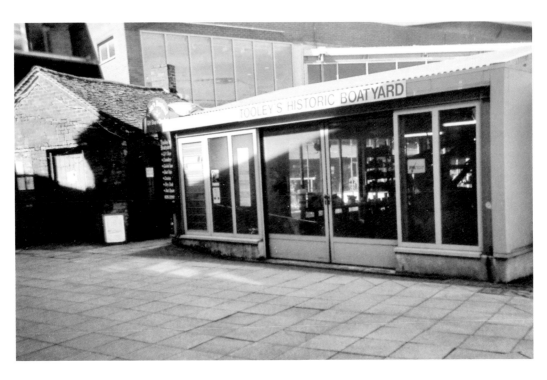

Banbury Quay

Photographed in Banbury Quay, Mr and Mrs Richard Littlechild from Dorset are passing through Banbury on their way to Oxford. What a delightful way to spend a holiday.

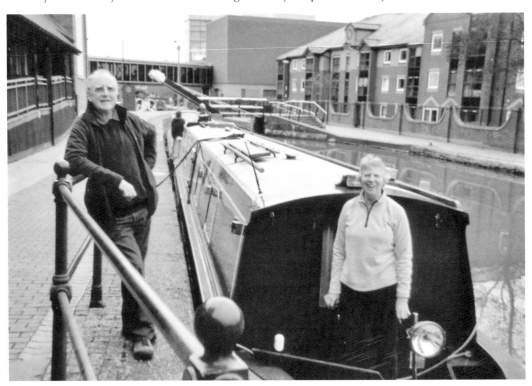

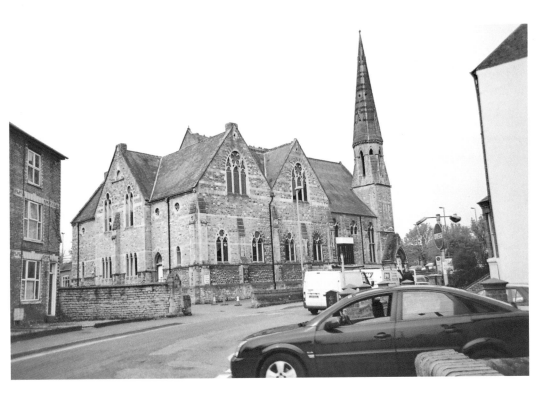

Methodist Church and Castle Quay Shopping Centre

In 1853 Dr Stanton developed the Beech Lawn Estate in Marlborough Road. Opened on 9 May 1865, the Methodist Church on Marlborough Road was the third to be built in the town. The first Methodist Church was on South Bar and the second was in Church Lane. Below is the impressive entrance to the Castle Quay Shopping Centre, formerly the Corn Exchange. It was built in 1857 and was converted into a pub in the 1880s.

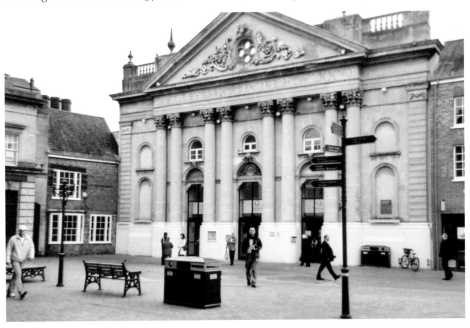

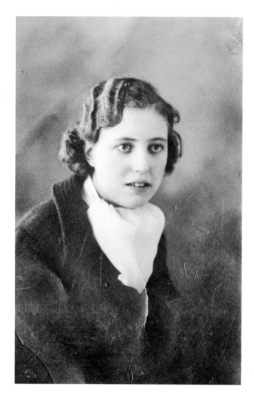
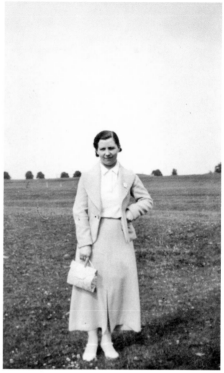

Rhoda Skelsey

I always include a family in my books and in the *Banbury Through Time* I have the pleasure of introducing Rhoda Skelsey of Box Hedge Lane. The pictures show Rhoda as a beautiful young girl, then as the lovely woman who married Sid Garrison in March 1938. They started married life at 6 West Rock, Warwick. Baby Margaret arrived in 1939 and Christine, her sister, came along later.

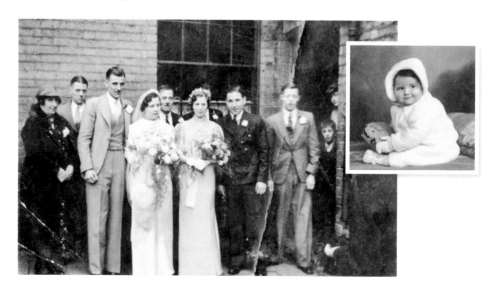

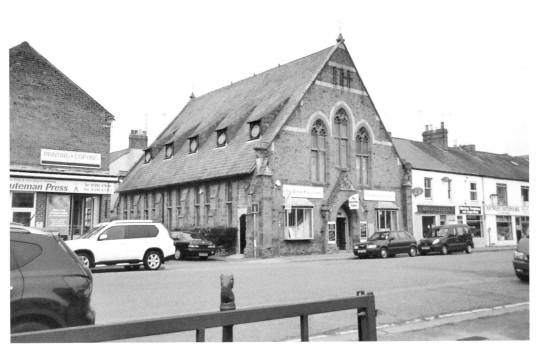

Oriel House

Built at the turn of the nineteenth century with local stone, Oriel House was originally Christchurch Parish Hall. In each of the ten openings in the roof is an oriel window, which is probably how the building acquired its name. It is currently being used as a 'bed and pine centre', but planning permission has been given to convert the building into new flats. The photograph below is of the Co-op, which was built in 1934 and had a reputation for being well stocked with affordable merchandise. On the first floor was a lovely café, which was accessible by the first public lift in Banbury.

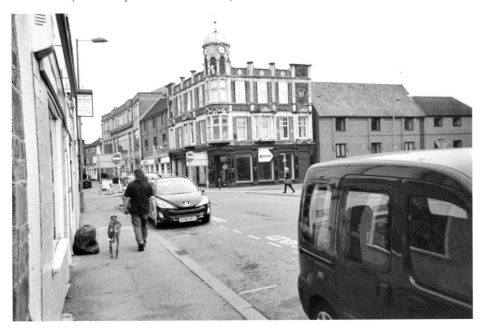

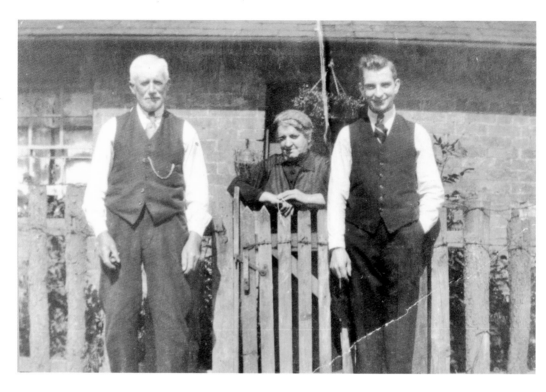

Bessie and George Cox

Bessie and George Cox at the garden gate with their middle son Tom. Married in Banbury, the family lived for a while in the cottages in Ratley, before moving to Radway. The photograph below shows the cottages as they look today.

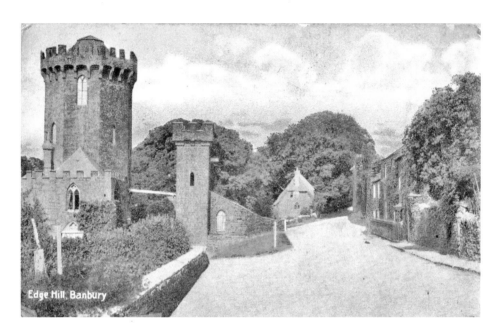

Edge Hill, Banbury

Edge Hill (I)

It is said that Charles I observed the famous battle between his own army and the Parliamentarians on Sunday 23 October 1642, from the site of the Edge Hill Tower. Designed after Guy's Tower at Warwick Castle, the tower was built by Sanderson Miller a hundred years after the battle, as a place of entertainment. The entrance to the tower was by drawbridge from the smaller tower. The Edge Hill commands a panoramic view of Warwickshire.

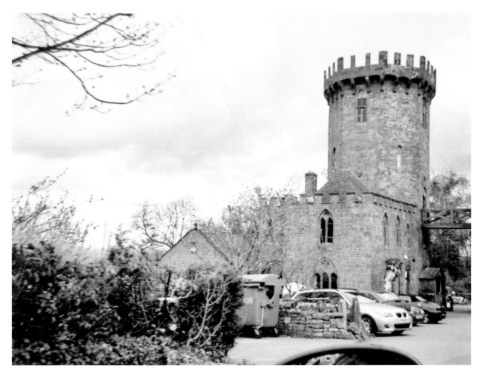

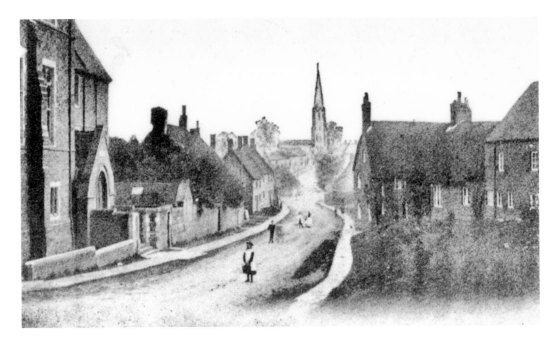

Bloxham

A lovely old print of Bloxham village in around 1900. You can see the spire of St Mary's and its 195-foot tower in the centre of the postcard. All Saints' School was founded by the Revd P. R. Egerto. Below is a delightful photograph taken by the late Graham Wilton of the Queen Mother, who visited the school in the 1960s.

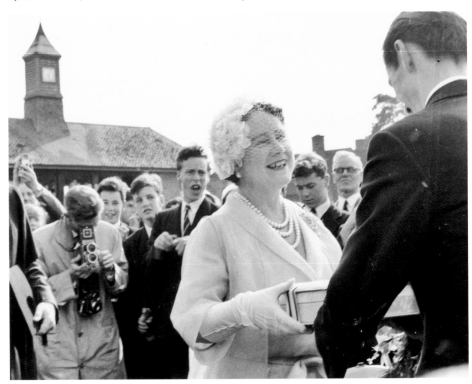

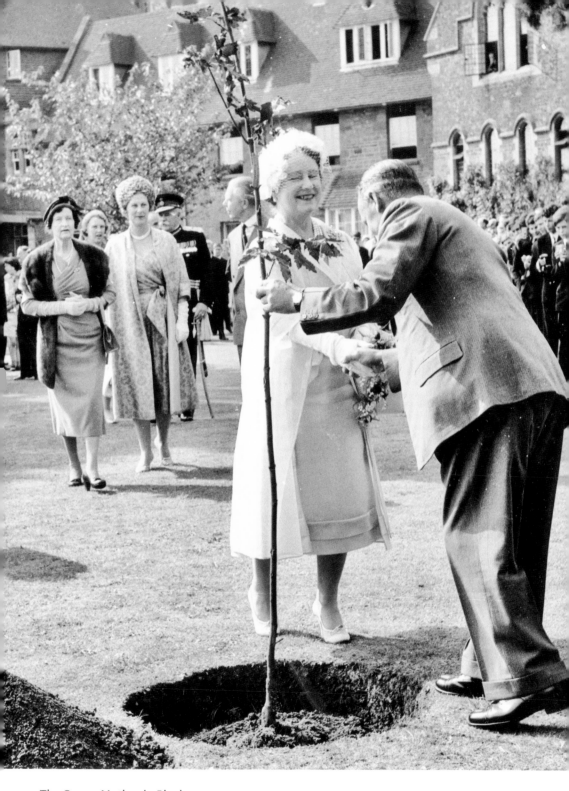

The Queen Mother in Bloxham
Another of Graham Wilton's photographs of the Queen Mother's visit to Bloxham.

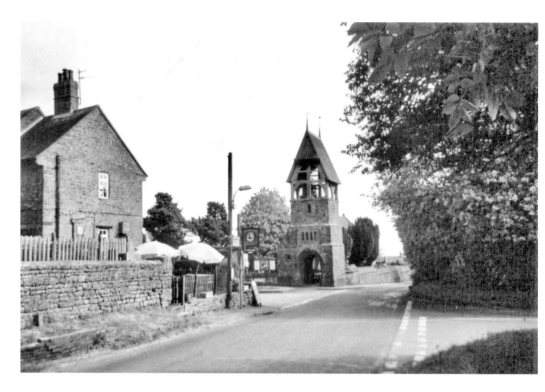

Great Bourton

The Bell Tower at All Saints' church, Great Bourton, is so unusual that I had to include it in the book. The vicar is the Revd Pat Freeth. The history of the bell tower and the church is on the wall of the Bell Inn, adjacent. The inn is a beautiful old building that, apart from being the local pub, has a coffee morning every Thursday. Although I was unable to accept my invitation to join the group for coffee on this occasion, I will certainly be taking up the landlady's offer in the near future.

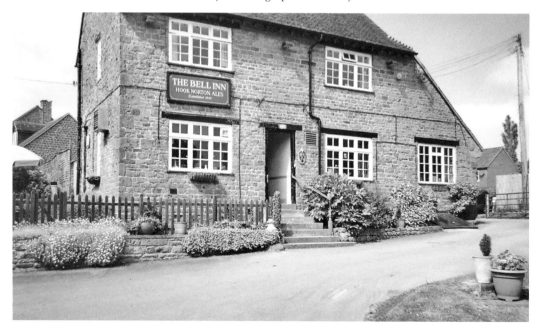

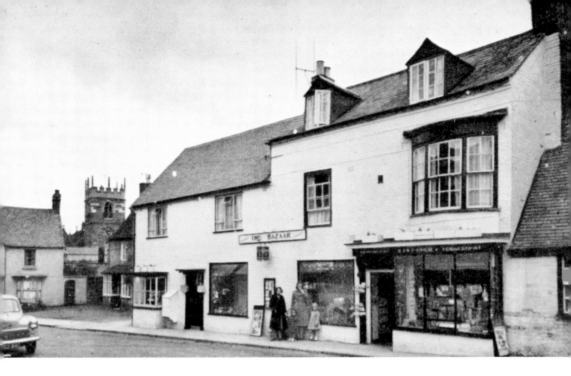

Shipston-on-Stour

Originally Shipston-on-Stour was a Saxon settlement known as Scepwaestune, meaning 'sheep wash town'. A ford runs by the town, which made it an ideal wool-washing area. These days, an annual wool fair takes place in May. Here we see Bradley's Bazaar as it once looked and how it looks now.

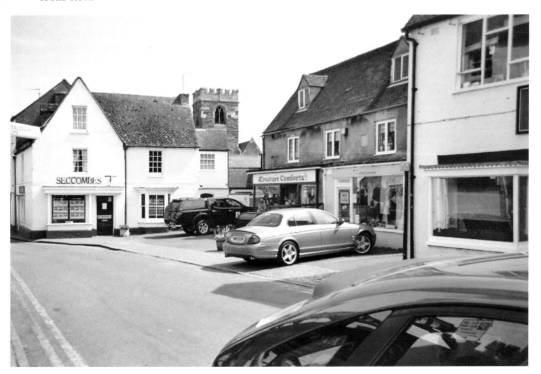

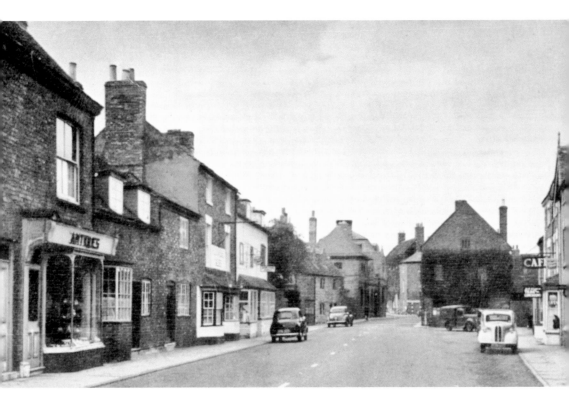

New Street, Shipston-on-Stour

The charm of this delightful corner of the world is its ability to celebrate the past yet embrace the talents and achievements of the present day. This is usually a busy road, but I was fortunate enough to be in town early on a Sunday morning.

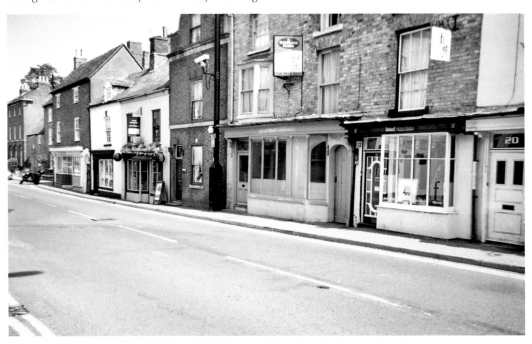

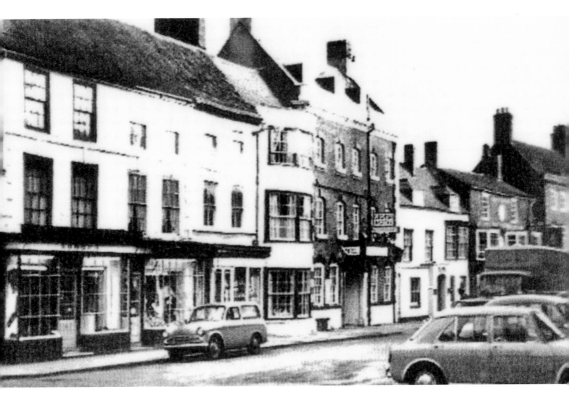

The High Street, Shipston-on-Stour

Shipston-on-Stour owes much to the passionate enthusiasm of traders and residents for its diverse range of shops, pubs, tearooms and fine restaurants. The White Bear is particularly popular, with its shining windows, polished tables and friendly staff.

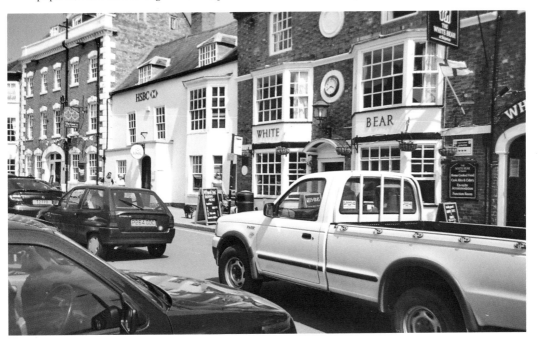

Antiques, Shipston-on-Stour
While in Shipston-on-Stour I came across these two lovely but totally different pictures of the town. The picture on the left is the town's antique shop, which was one of those good old shops that you could dig around in for ages. Mrs Savage, below, was waiting for her friend to join her for Sunday lunch.

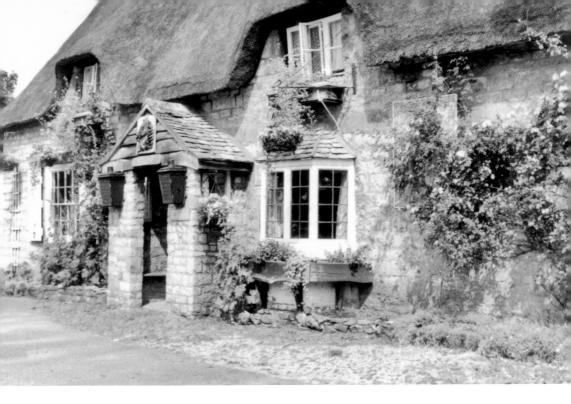

The Black Horse, Shipston-on-Stour
This old pub can be found on the outskirts of the marketplace in Shipston-on-Stour. The 'olde world' interior is well worth a visit.

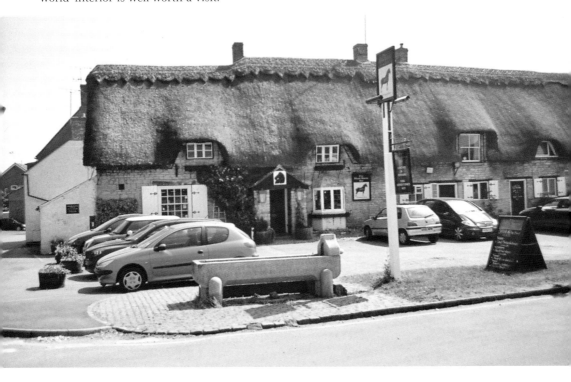

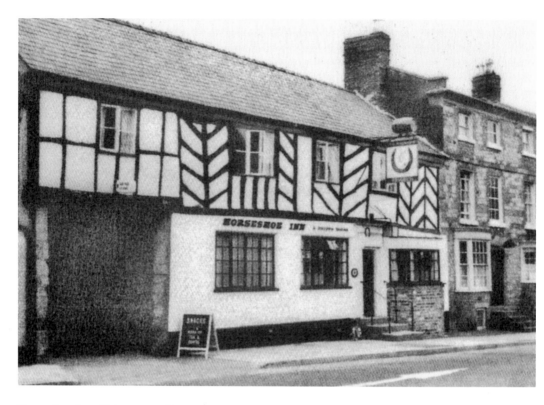

Horseshoe Inn, Shipston-on-Stour

The Horseshoe Inn, also in Shipston-on-Stour, has changed very little over the years. Opposite the inn is the back of a distillery, here decked in red flags to mark the occasion of Prince William's marriage to Kate Middleton.

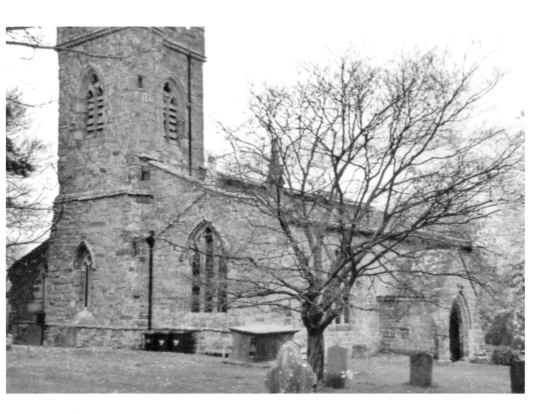

Hanwell Church

As you enter the church you will find on your left two biers, one of the hand-carry design dating back to 1833, the other a Victorian bier with four wheels. A fine Elizabethan chalice with a cover engraved '1574' is also kept in the church.

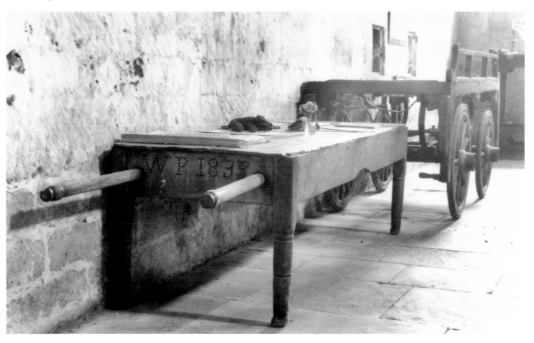

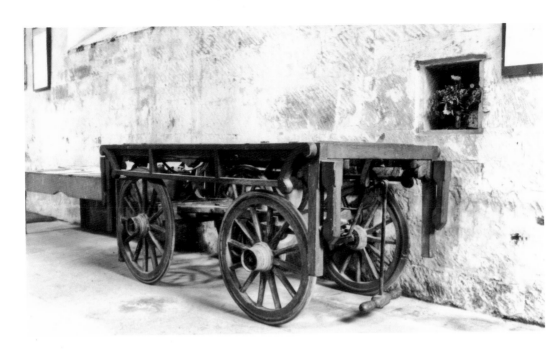

Hanwell Castle

The picture above shows a close-up of the wheeled bier from the previous page. The castle at Hanwell dates back to 1498. It was built of brick, with stone dressings, and is the earliest known. The use of brick in a stone belt is unusual. The castle was lived in by four generations of Copes until 1714. Later it was converted into a farmhouse. Much of the original building had been demolished by 1902.

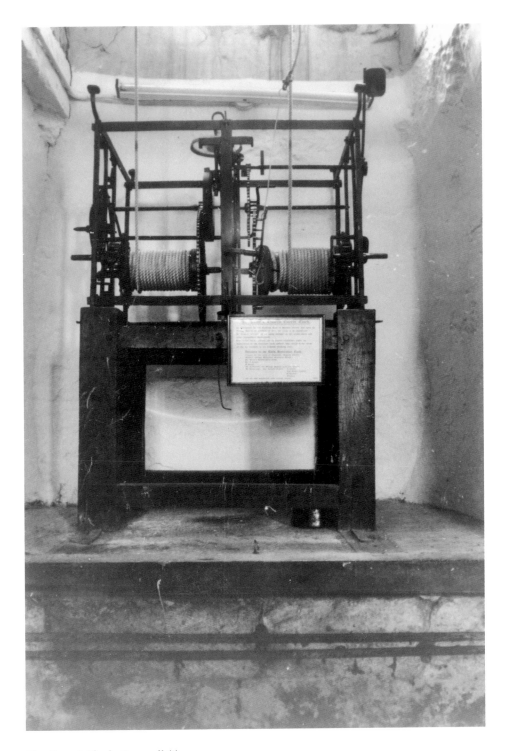

The Turret Clock, Hanwell (I)
St Peter's church in Hanwell is steeped in history as not only does it have the famous Turret clock in its west wall, which is in perfect working order, it also has an open fireplace, which is quite unusual in this day and age.

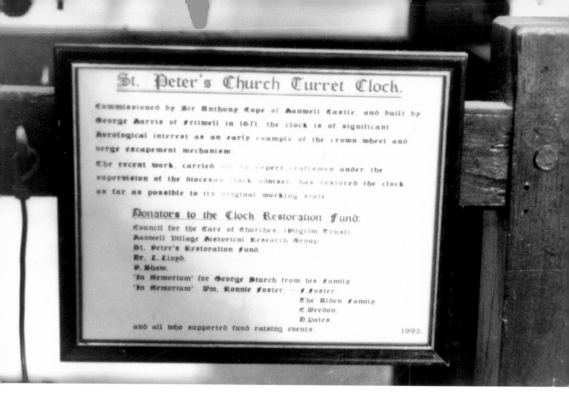

St. Peter's Church Turret Clock.

Commissioned by Sir Anthony Cope of Hanwell Castle, and built by George Harris of Fritwell in 1671, the clock is of significant horological interest as an early example of the crown wheel and verge escapement mechanism

The recent work, carried out by expert craftsmen under the supervision of the diocesan clock adviser has restored the clock as far as possible to its original working state

Donators to the Clock Restoration Fund:

Council for the Care of Churches (Pilgrim Trust)
Hanwell Village Historical Research Group
St. Peter's Restoration Fund.
Dr. K. Lloyd.
P. Shaw.
'In Memorium' for George Sturch from his family
'In Memorium' Wm. Ronnie Foster. - J Foster.
The Alden family.
E.Weedon.
D.Bates.
and all who supported fund raising events. 1992.

The Turret Clock, Hanwell (II)

Turret clocks do not have faces. There are many more interesting things to be found in this delightful little church adjacent to Hanwell Castle, including an open fireplace.

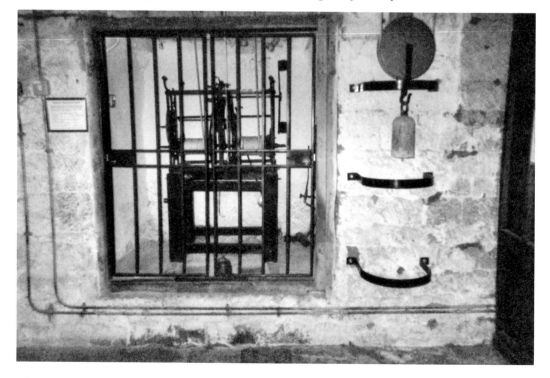

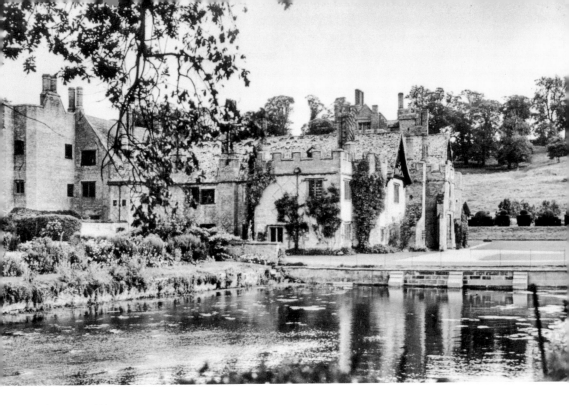

Compton Wynyates

Built on the site of a Norman manor house, this beautiful building was built between 1480 and 1520. Fulbrook Castle, a ruin given to William de Compton by Henry VIII, supplied much of the stone the house was built from. It is now home to a lovely art gallery.

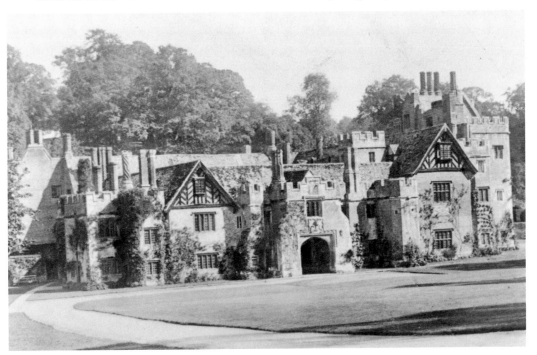

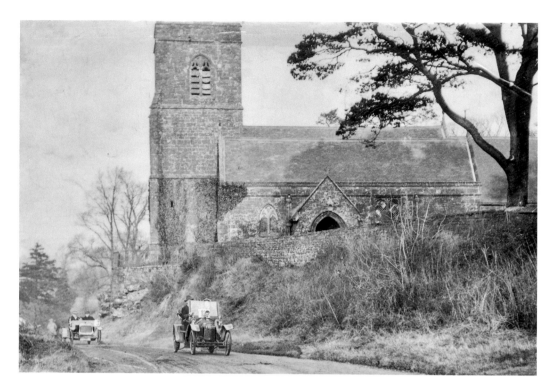

Warmington Hill

The Warwick-to-Banbury road will take you through Warmington. This delightful photograph shows lovely old cars passing Warmington church. The cars have numbers on them, which suggests some sort of race. In contrast, today's motor cars tackle the hill with ease.

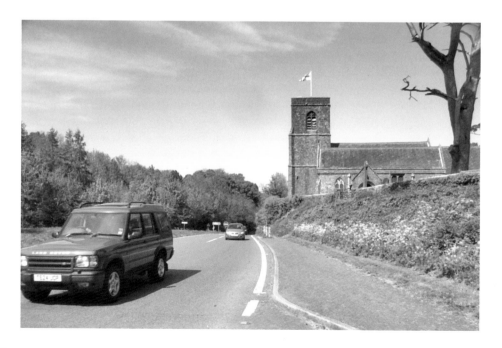

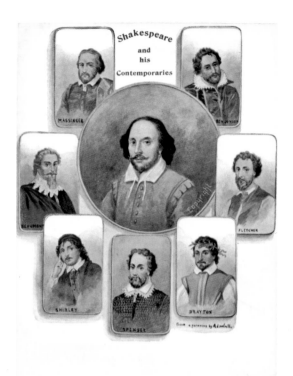

Shakespeare and Stratford-upon-Avon
Above we see Shakespeare and his counterparts. Below is the newly revamped Shakespeare Memorial Theatre. Visitors can climb the tower, which gives panoramic views of the area.

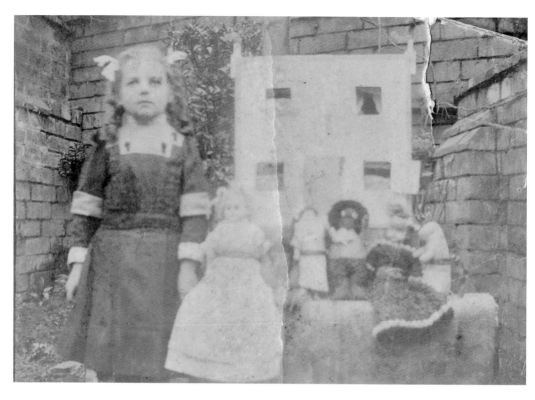

Two Old Photographs
These two lovely old photographs that were given to me when a friend's relative passed away.

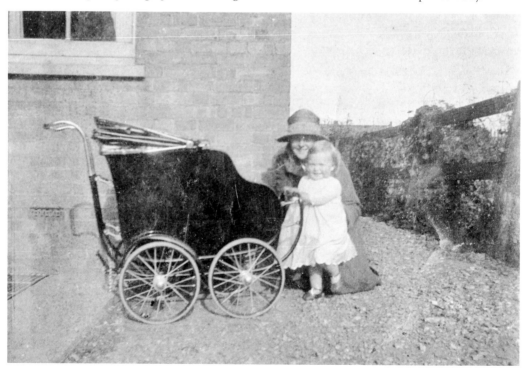

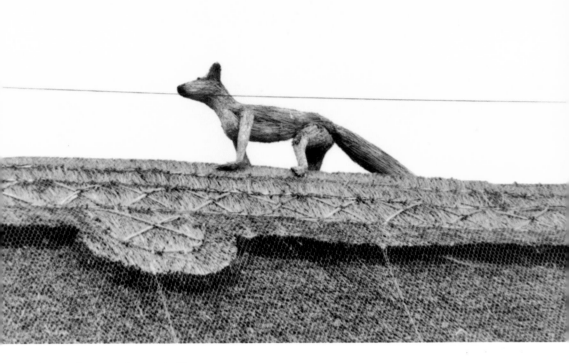

Straws Cottage, Cropredy (I)

This little gem can be found running across the thatched roof of Straws Cottage, situated near the village green in Cropredy. The fox, which is made of thatch, was the thatcher's trade mark. The photograph below shows the old canal wharf in Cropredy, just down the road from the fox.

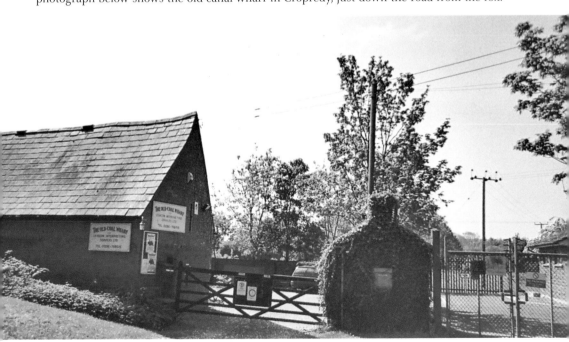

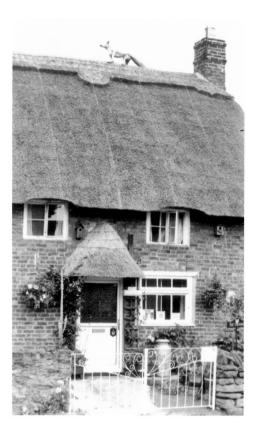

Straws Cottage, Cropredy (II)

I came across this old thatched cottage years ago when I was out filming with my old friend Geoff Parker, who took the black-and-white photograph. I returned to Cropredy to see what changes had occurred and was pleased to see that the fox has also stood the test of time. Sadly, Geoff Parker didn't; he has recently passed away.

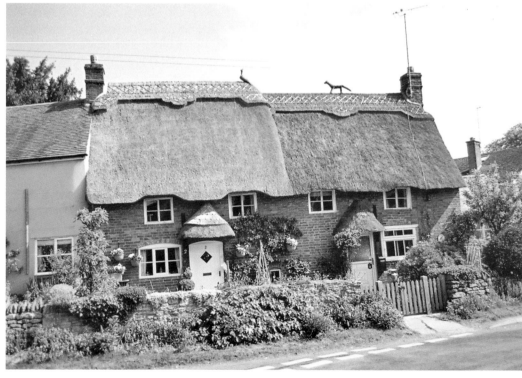

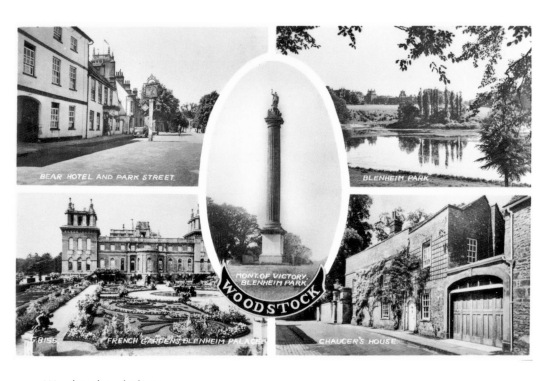

Woodstock and Kineton

I am including many images of Banbury's neighbouring villages. Here we see Woodstock and Kineton.

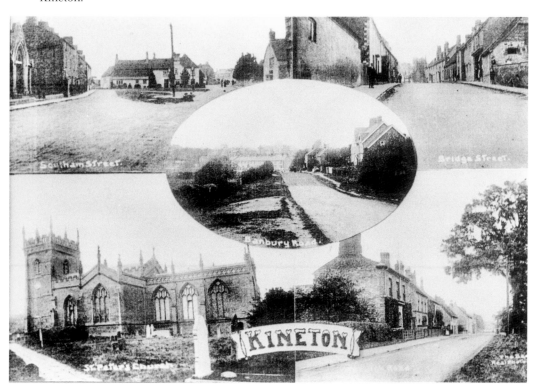

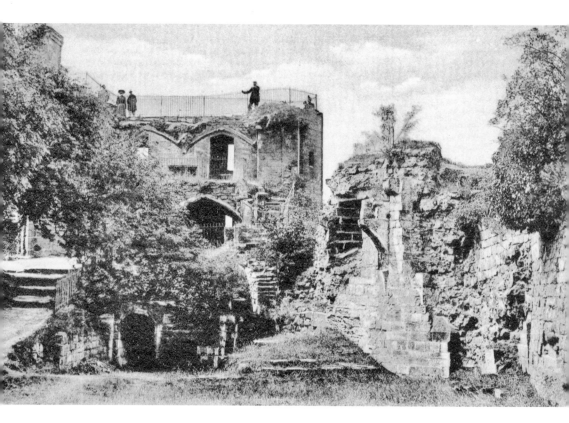

Kenilworth Castle (I)
Warwickshire has its fair share of castles and here we see two different views of Kenilworth Castle.

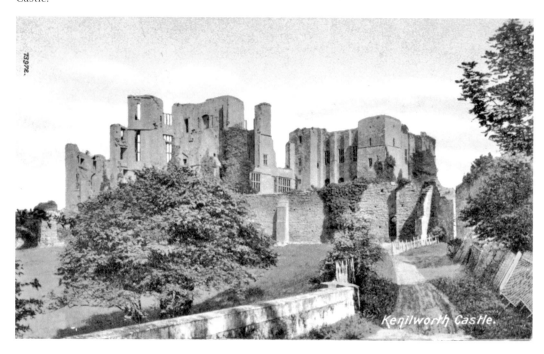

Kenilworth Castle.

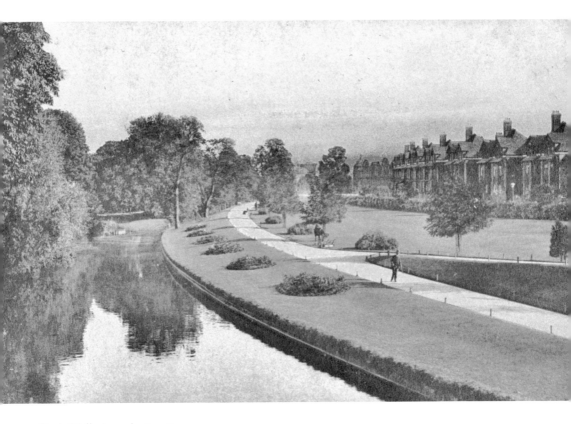

York Walk, Leamington Spa
The York Promenade, a lovely river walk, early in the last century.

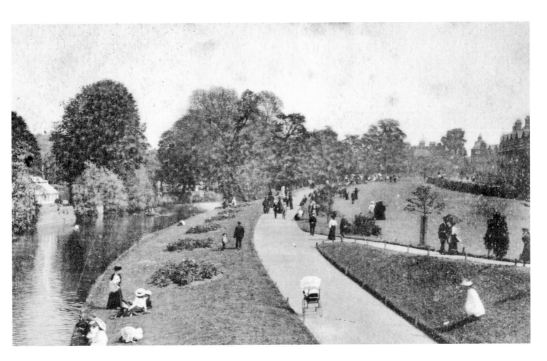

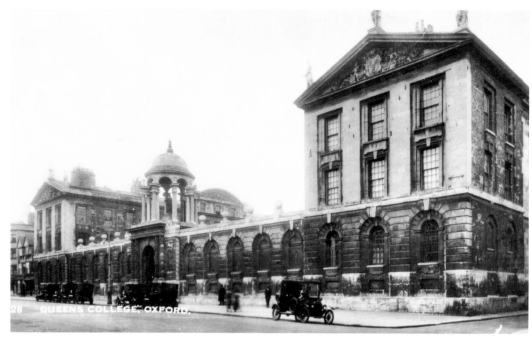

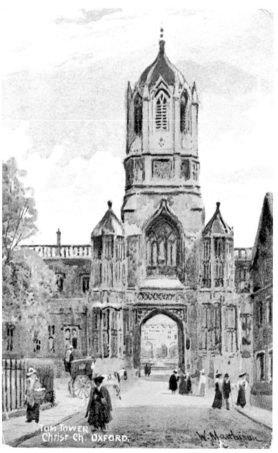

Oxford (l)
Two postcards of the shire town. The postcard above shows the Queen's College; the photograph below shows Tom Tower, Christ Church.

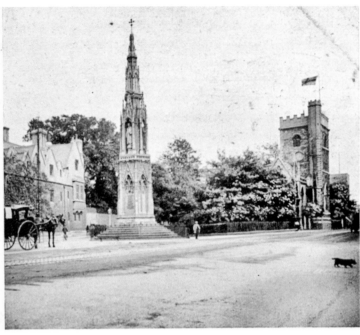

Oxford (II)
Two more views of the shire town.

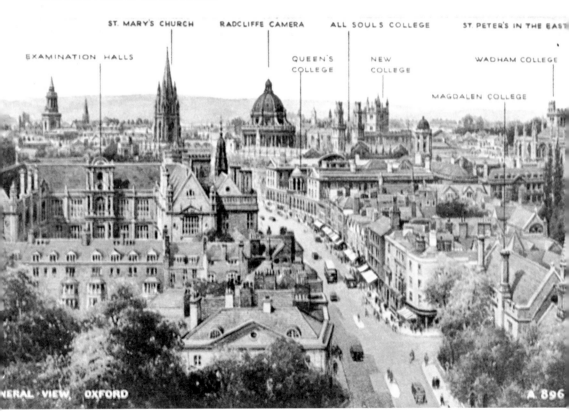

EXAMINATION HALLS ST. MARY'S CHURCH RADCLIFFE CAMERA ALL SOULS COLLEGE ST. PETER'S IN THE EAST

QUEEN'S COLLEGE NEW COLLEGE WADHAM COLLEGE

MAGDALEN COLLEGE

NERAL · VIEW, OXFORD A 896

Edge Hill (II)
The locals claim that to this day the ghosts of the Battle of Edge Hill can still be heard on a dark 23 October evening.

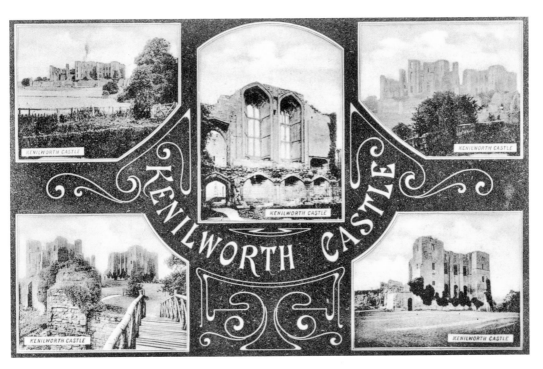

Kenilworth Castle (II)
A collection of views of Kenilworth Castle.

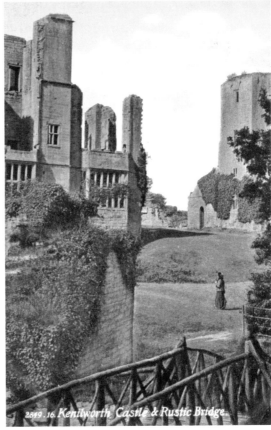

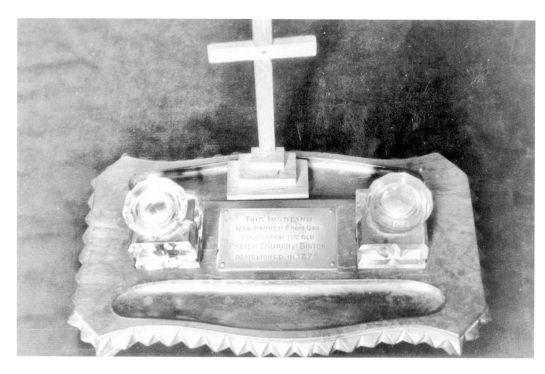

Binton Church (I)

The photograph above shows an ink stand in St Peter's church, Binton. It was carved from the wood of the original parish church, which was demolished in 1875. It was presented to the church by the Marquess of Hertford when the present building was erected in 1876.

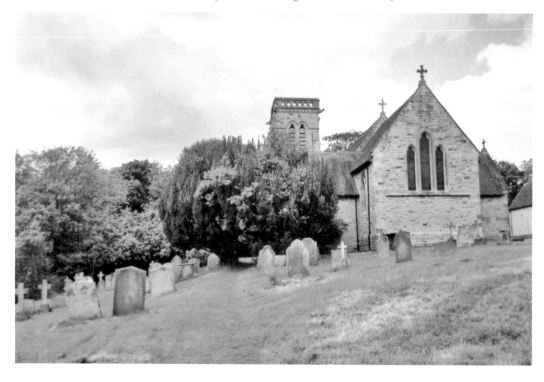

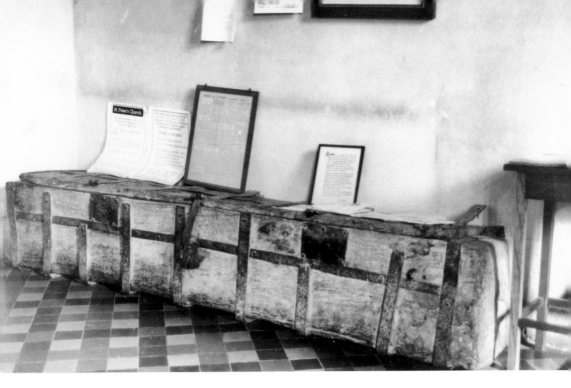

Binton Church (II)

The photograph above shows an unusual 8-foot-long chest, which can be found just inside the church entrance. It is probably over 500 years old. The church is full of surprises. When the photograph below was taken, the organ was operated by bellows. Here we see the author 'having a go'.

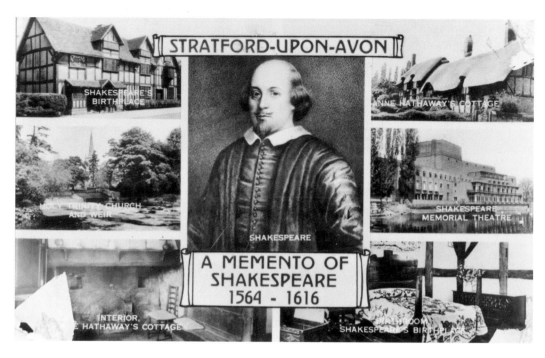

Hall's Croft, Stratford-upon-Avon
A rare glimpse of the kitchen at Hall's Croft, which was the home of John Hall, Shakespeare's son-in-law. He married Susannah Shakespeare in 1607 and they had one daughter, Elizabeth.

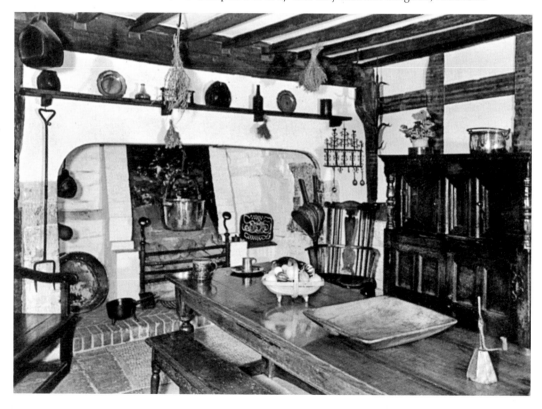

Anne Hathaway's Cottage, Stratford-upon-Avon

The oldest of three daughters born to John Hathaway, a farmer, lived in Shottery. Anne Hathaway married William Shakespeare when he was eighteen years old. She was eight years older than he was.

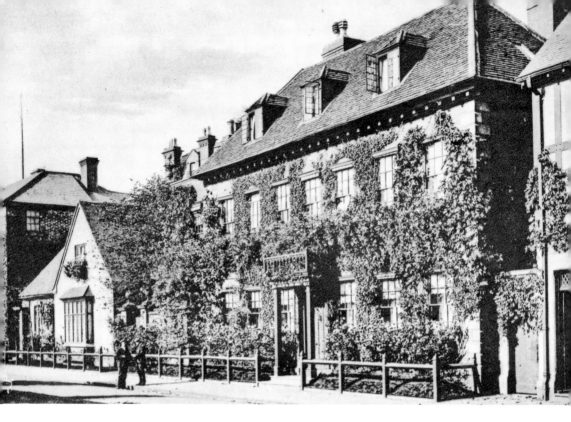

Mason Croft, Stratford-upon-Avon
This lovely old house was the home of Marie Corelli, a popular novelist, who came to live in Stratford-upon-Avon in 1899. The house stands in Church Street. Among the novelist's many claims to fame were her novels *The Sorrows of Satan* and *Barabbas*.

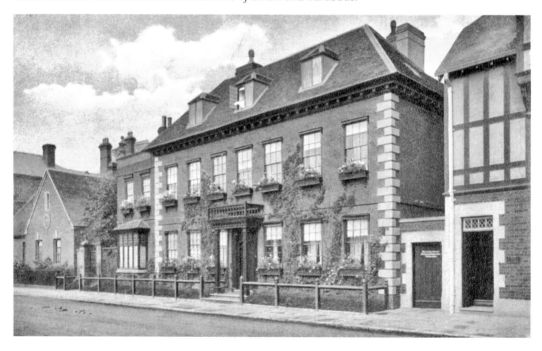

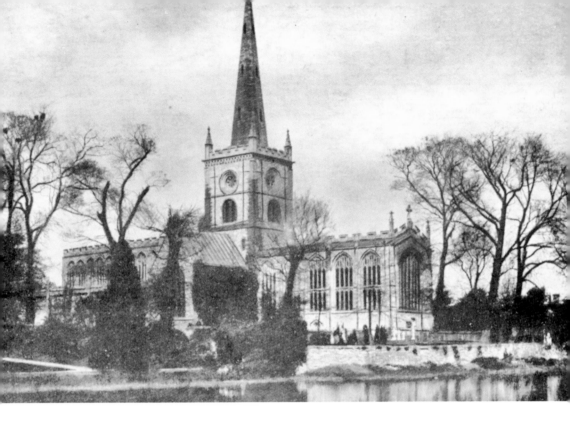

Holy Trinity, Stratford-upon-Avon (I)
Two totally different postcards show Holy Trinity Church, which stands by the River Avon. It is here where the bard rests.

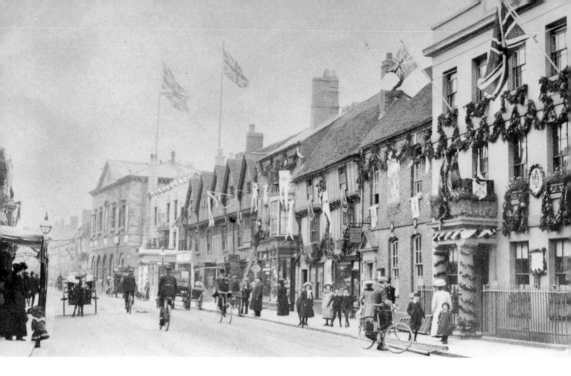

Shakespeare's Birthday, Stratford-upon-Avon
Stratford-upon-Avon is dressed up to mark the occasion of William Shakespeare's birthday in 1907. In contrast, the road looks very drab today.

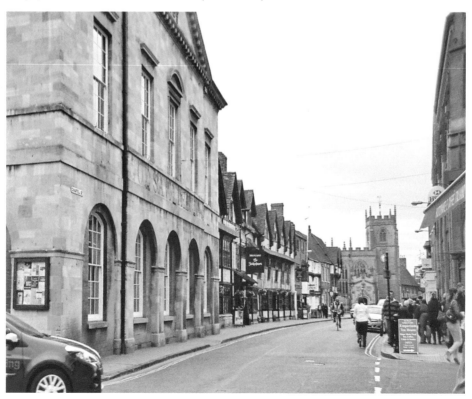

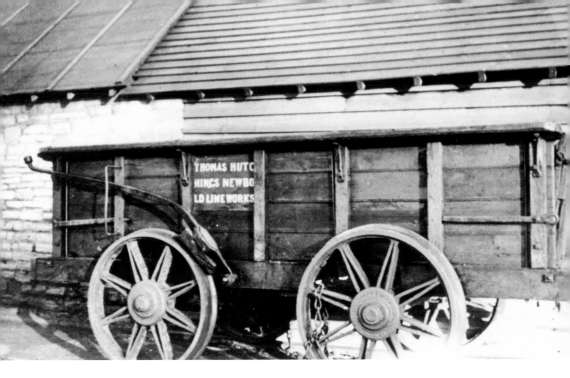

Thomas Hutchings' Wagon, Stratford-upon-Avon

This lovely old wagon was one of the wagons used on the Stratford and Moreton tramway in 1826. It ran 16 miles to the market town of Moreton-in-Marsh, with a branch line to Shipston-on-Stour. The wagon was restored in 2010. The wagon rails and stone blocks are original pieces of the Moreton tramway.

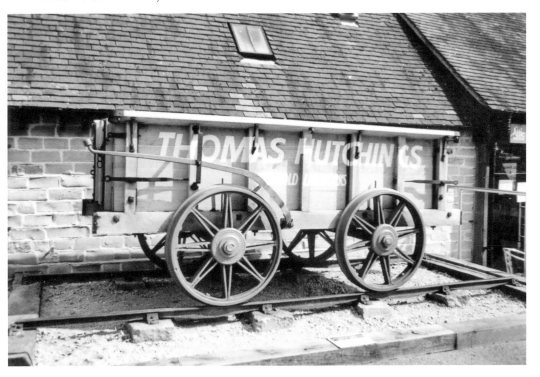

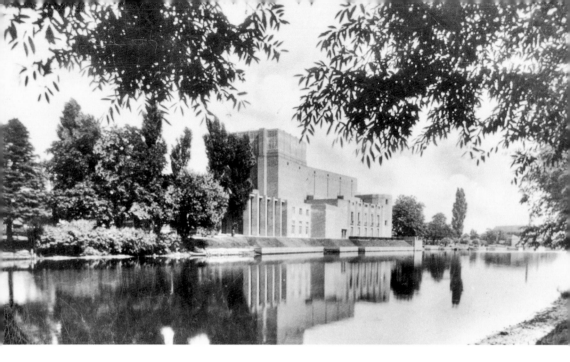

The Shakespeare Memorial Theatre, Stratford-upon-Avon
Two contrasting views of the Shakespeare Memorial Theatre. The postcard above was taken before the balcony café was opened. The theatre came about from the generous donations of Shakespeare devotees in the United States in 1932. Elizabeth Scott, the great-niece of the renowned architect Sir Gilbert Scott, won an open competition to design the theatre.

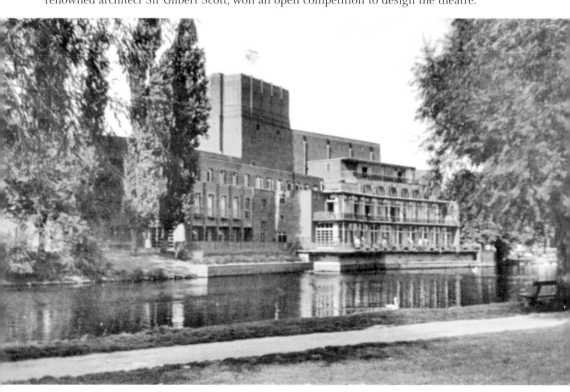

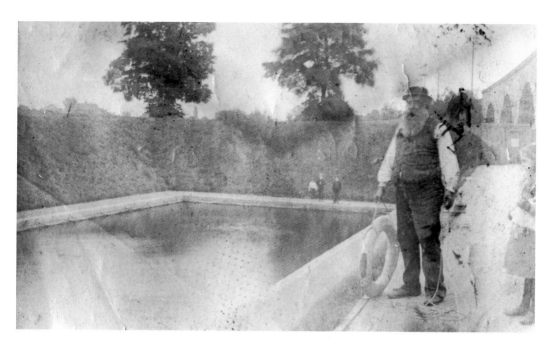

Leamington Spa's Old Open Swimming Pool

Here we see Frederick Rice of E. K. Pacey working at the old open-air swimming baths on York Walk. The photograph below shows the viaduct with a train crossing. The baths were close to the viaduct, as you can see in the picture above.

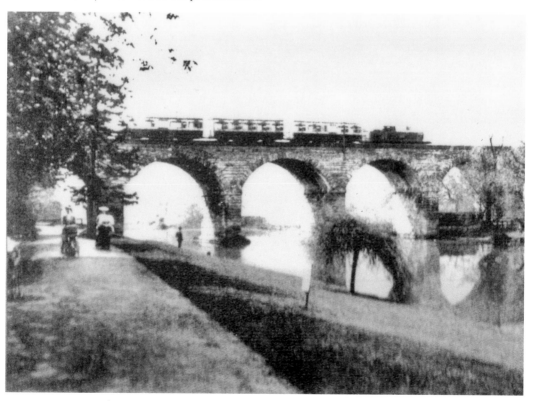

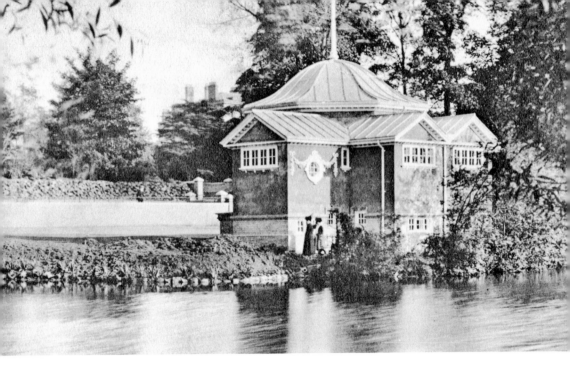

The New Bandstand, Leamington Spa
What memories these postcards bring back to me. Concerts were held in the Jephson Gardens. Once, my neighbour and I were a few minutes late to a classical concert one Sunday evening. Unfortunately, our seats were at the front of the theatre. Upon seeing us, the conductor tapped the baton on the stand, stopped the orchestra, glared at us, and tutted. Happy days.

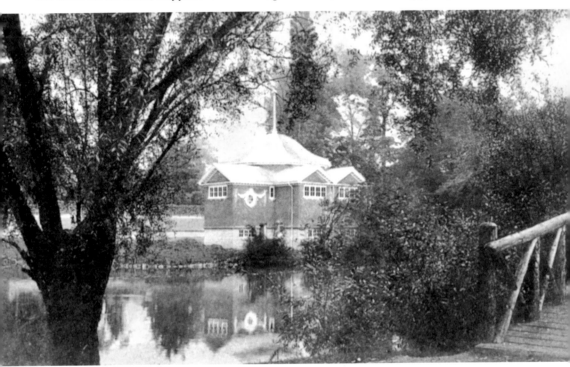

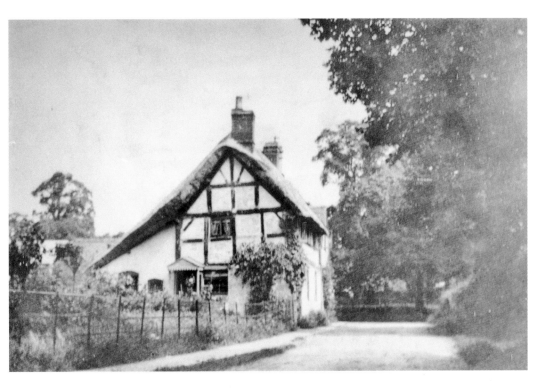

Ladbrooke

This delightful house stands in Ladbrooke. The tranquil lane has changed over the years but it is still a tranquil place to visit.

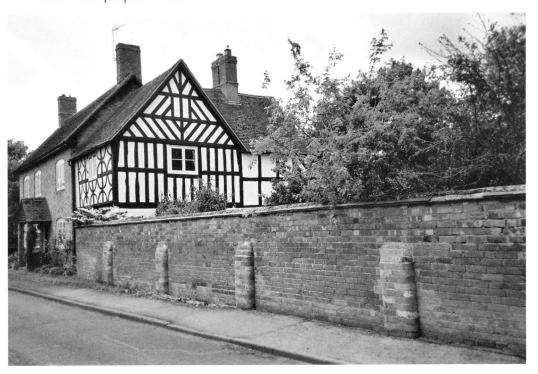

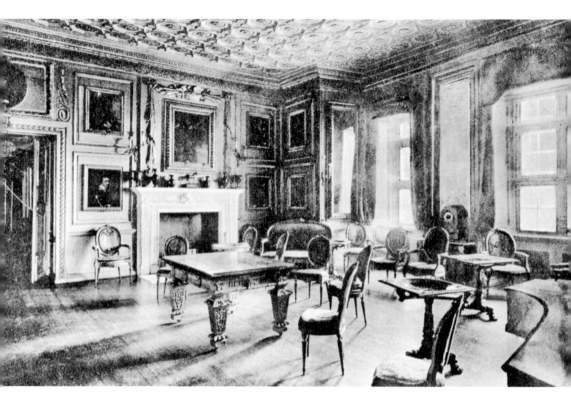

Warwick Castle

The Gilt (or Green) Dressing Room at Warwick Castle. Below is a lovely postcard view of the castle, as seen from the bridge.

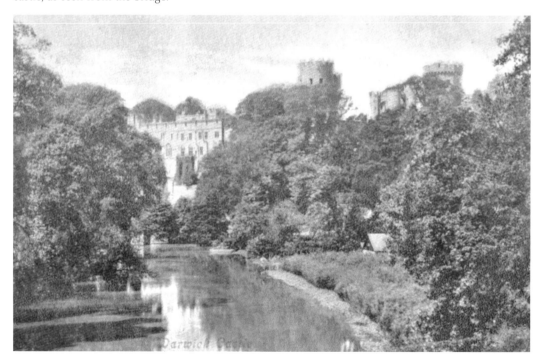

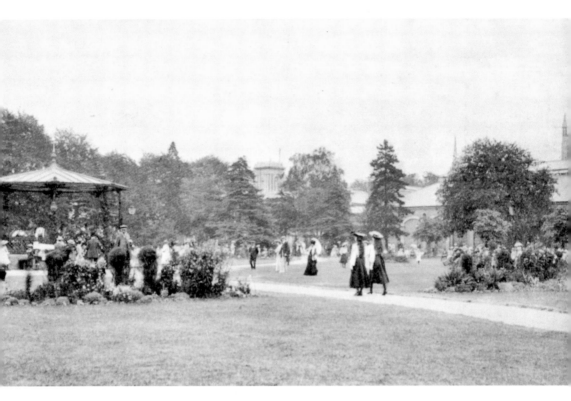

The Pump Room Gardens, Leamington Spa

The Pump Room Gardens became a place of fashion in the summer evenings. The town's people would put on their finery and spend an evening listening to the band playing in the bandstand, which can be seen in the centre of the gardens.

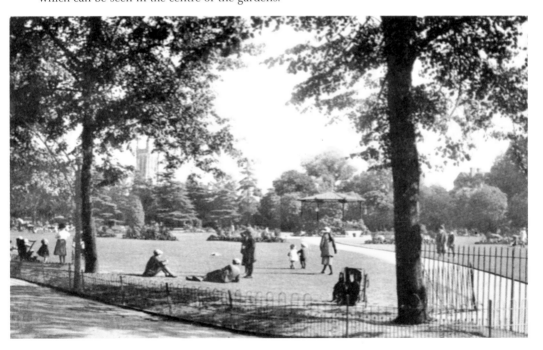

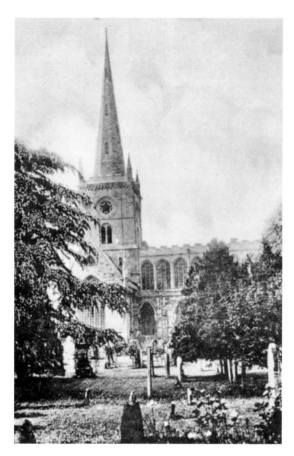

Holy Trinity, Stratford-upon-Avon (II)
This is the place where the Bard rests.
Visitors from all over the world come to
the church to pay their respects.

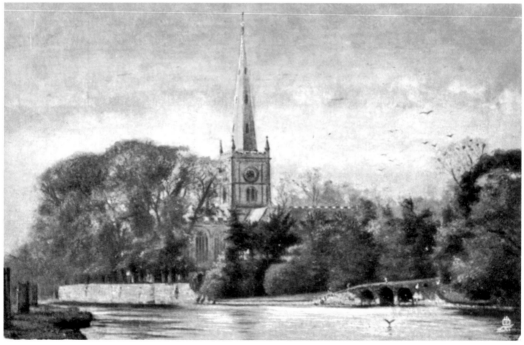

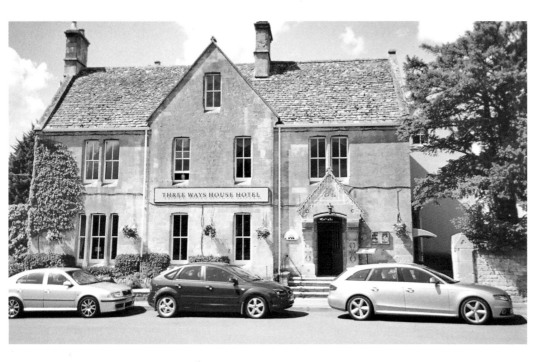

The Pudding Club

Here we see the Three Ways Hotel, Mickleton. The hotel introduced the now-famous Pudding Club to the area in the 1980s 'to prevent the demise of the great British Pudding'. Below is the Parade of the Puddings.

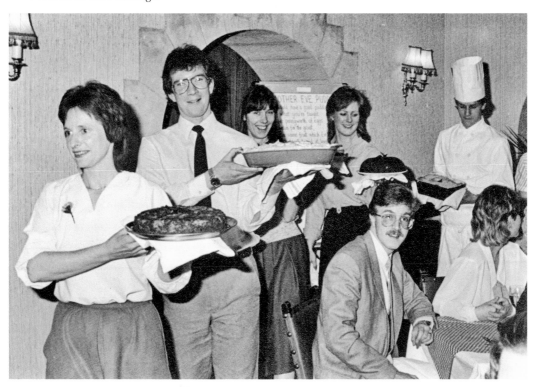

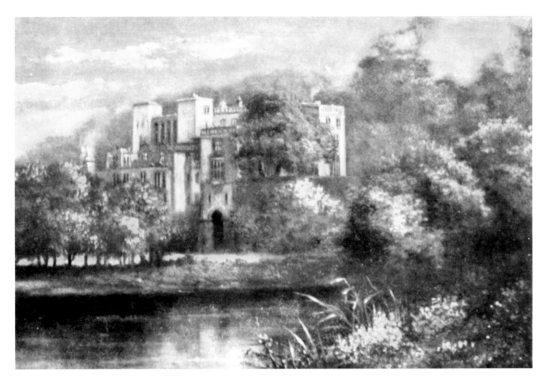

Warwick

Two delightful colour postcard views. The picture above shows Guy's Cliff House and the postcard below shows Mill Street. I love old postcards and thank Austria – the first country to produce souvenir postcards, in 1869 – for the opportunity to share them with you.

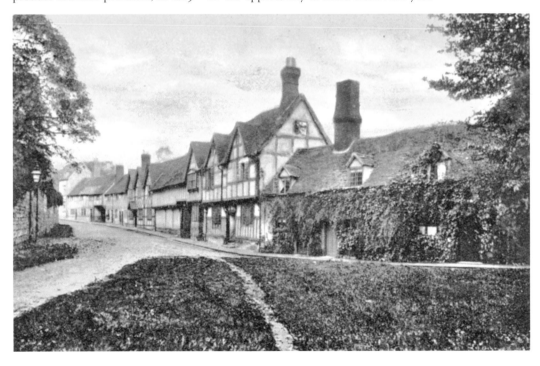

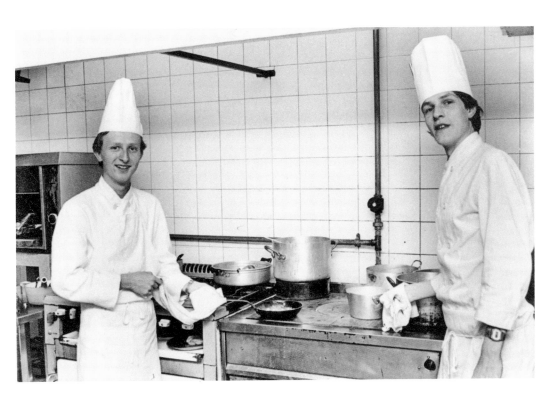

A Master Butcher, Mickleton

Two chefs in the kitchen of the Three Ways Hotel, Mickleton, in January 1986. Below we see Mr Davis, the master butcher, stood outside his butcher's shop in the village. Mr Davis took over the business from his old boss Clive Porter, who retired. He still only stocks locally reared meat, which he supplies to many hotels and businesses in the area. His customers come from far and wide to buy his meat, which is of the highest standard.

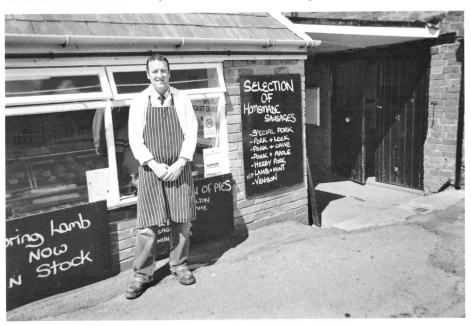

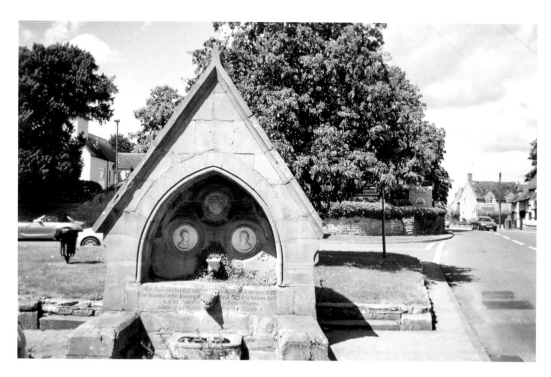

Mickleton

This monument was erected to mark the occasion of water coming into the village and can be seen on the green opposite the Three Ways Hotel. The picture below shows the local press enjoying the puddings and the grand opening of the Pudding Club.

Brinklow and The Jephson Gardens, Leamington Spa
The postcard above is of the ancient tumulus and Roman camp at Brinklow. Below we see the lake in the Jephson Gardens, Leamington Spa, before the fountains were installed.

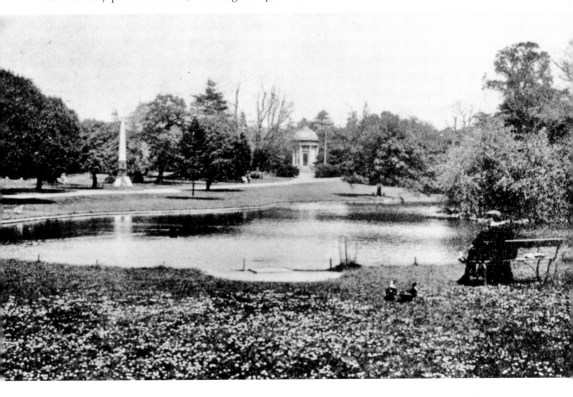

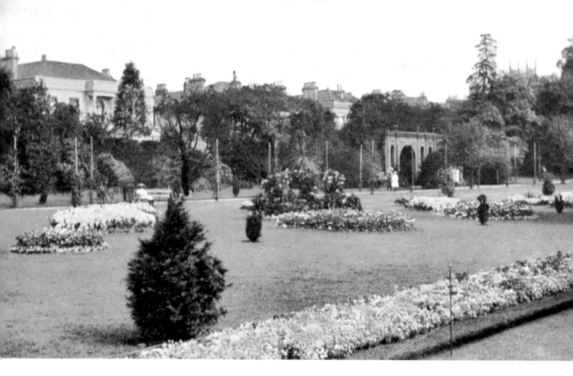

The Jephson Gardens, Leamington Spa

The postcard above shows Leamington's famous flowerbeds, which have contributed to the town's frequent success in Britain in Bloom. The postcard below shows the lake before the days of the fountains and gives us a rare look at the gardens in their early days.

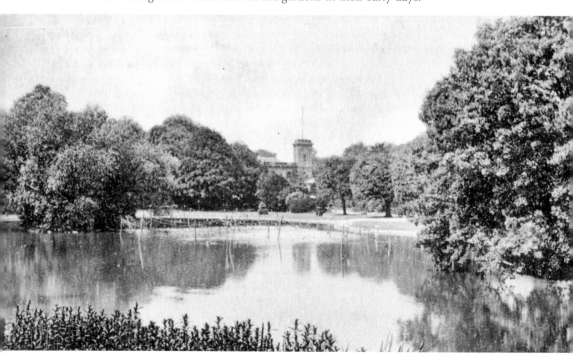

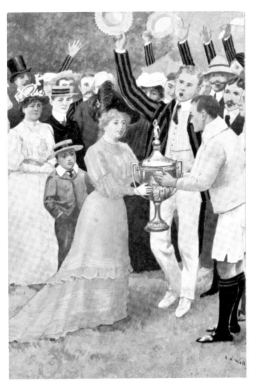

Stratford-upon-Avon Boat Club and River Stour

I have included these lovely old postcards for the card collectors among our readers. The one above shows Miss Marie Corelli presenting a cup to the Stratford-upon-Avon Boat Club; the other is of Flatford Mill on the River Stour.

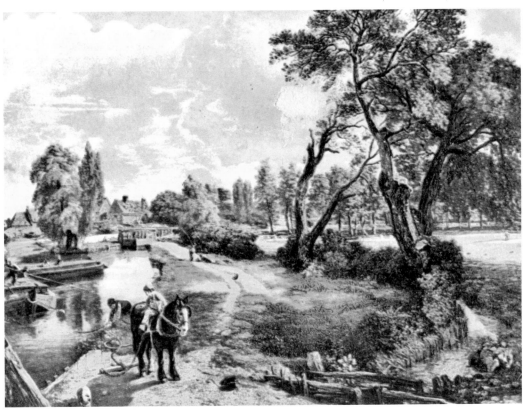

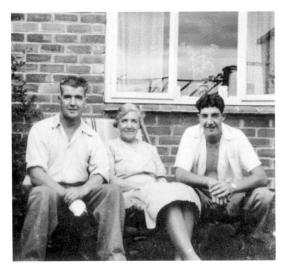

The Ruscote Estate

Meet the Bennett family, who for many years lived on the Ruscote Estate. Above: Beck Bennett, who worked at the aluminium works (affectionately known among the locals as 'the Alley'), Ivy Bennett and Reggie Bennett. Left: Ivy's children Joyce, Reggie and young Ivy. Below left: Granny Davis, Margaret Garrison and Margaret's mother Rhoda, a Banbury lass. Below right: Rhoda Garrison and Ivy Bennett in August 1937.

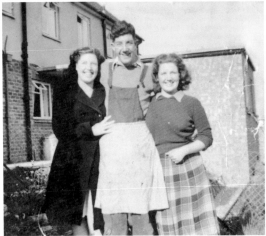

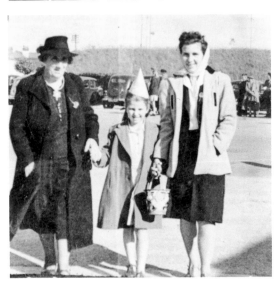

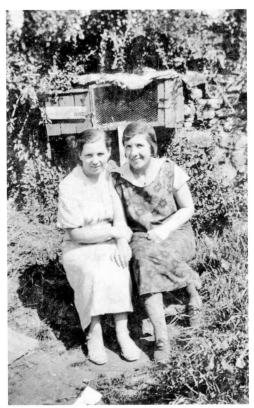

The Lovers' Rest, Warwick

On the back of this lovely old postcard is printed the following verse:

Here you may sit and rest awhile,
And watch the wild ducks dive in play,
Listen to the cooing Dove, and the noisy jay,
Watch the moor-hen as she builds her rushy nest
Swaying upon the immortal Avon's heaving breast.

The bench can be found besides the Saxon Mill in Warwick, which is pictured below. It is a lovely, romantic building.

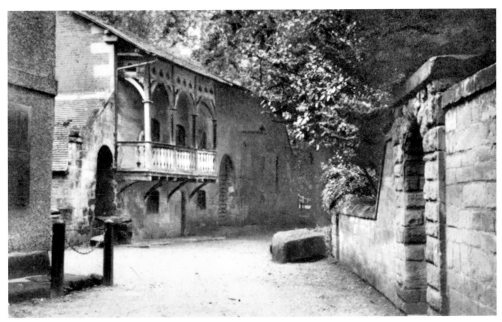

Berkswell and Leamington Spa
Above is the well in Berkswell; below is Linden Avenue in Leamington Spa, which skirts the Jephson Gardens.

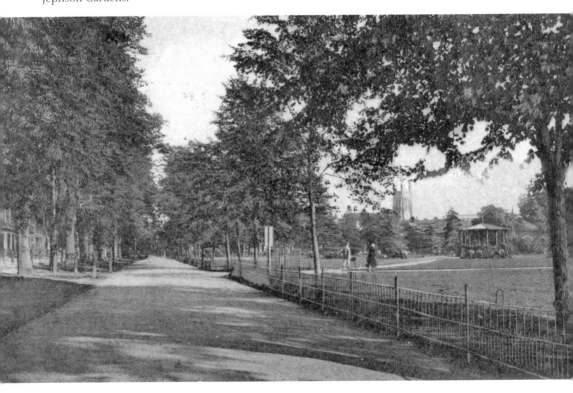